IMAGES
of America

WHITESBORO

D1370420

ON THE COVER: Sperry's Carriage Works is pictured around 1900. Charles T. Sperry operated a carriage manufacturing and blacksmith shop on the north side of the Erie Canal at Westmoreland and Canal Streets. His grandson Charles B. Sperry's book *Whitesboro, My Home Town* (1984) tells how Sperry was approached by an automobile-manufacturing company to build car bodies that resembled carriages. He saw no future in the business and turned it down. Another carriage business accepted the offer and moved to Detroit, later becoming the Fisher Body Corporation. Shown are the family members; Charles B. Sperry is the little boy holding the horse's reins. (Courtesy of the Whitesboro Historical Society president, Charles Sperry's great-grandson Burton Sperry.)

IMAGES
of America

WHITESBORO

Dear Len,
To my neighbor
who taught me to garden

Judy Harp Mallozzi and
Dana Nimey Olney

Judy Harp Mallozzi

ARCADIA
PUBLISHING

Published by Arcadia Publishing
Charleston, South Carolina

Printed in the United States of America

Library of Congress Control Number: 2014941400

For all general information, please contact Arcadia Publishing:
Telephone 843-853-2070
Fax 843-853-0044
E-mail sales@arcadiapublishing.com
For customer service and orders:
Toll-Free 1-888-313-2665

Visit us on the Internet at www.arcadiapublishing.com

To Hugh White, our founder; to his friends, the Oneida Indians; and to the Whitesboro Historical Society and Museum for collecting and preserving this history.

CONTENTS

ACKNOWLEDGMENTS

Many people contributed pictures and information that made this book possible; to them, the authors are grateful. If it had not been for the enthusiasm, interest in history, and computer skills of Whitesboro village clerk Dana Nimey Olney, this wish of three years would not have happened. We acknowledge, in alphabetical order, the following: Jim Ashton; Mary Centro; Anthony and Carol Bowen Curtacci; Jim Dimbleby; Carol Gifford Donohoe; Nancy and Don Hartman; Jean Head; Gert Hovey; Brian Howard of Oneida County Historical Society; Dennis Kininger, Dunham Public Library research librarian; Peter Manna; Teddie White Mulceahy; Joseph Petronella; Richard and Linda Pugh; Peter Riemersma; D. Gordon Rohman; Jim Service; Betty Siedsma; Peter Schinbal; Mr. and Mrs. Roger Skinner; Burton Sperry; Margaret Stephenson; Marian Vincent; Carol and John Warner; Richard Williams; Whitesboro Alumni Association; Whitesboro Presbyterian Church; Whitesboro Historical Society; Jan Zabek; and Rosemary Zombik. Many of the pictures are from the Richard Pugh postcard collection and the D. Gordon Rohman collection. Unless otherwise indicated, images are from the Whitesboro Historical Society collection.

INTRODUCTION

In March 1788, at the time it was formed, Whitestown, called "Mother of Towns," extended westward to Lake Erie and from the Pennsylvania border to the south all the way to the Canadian border to the north. From this vast expanse came 28 counties and more than 400 towns encompassing an astonishing 12 million acres. The Sadaqueda Patent was jointly owned by Zephaniah Platt, the father of the late judge Jonas Platt; Ezra L'Hommedieu; and Melancthon Smith. It was later purchased by Hugh White.

Hugh White's journey began in March 1784, upon earning a tract of land in New York. He left Middletown, Connecticut, with his family and traveled along the Mohawk River, finally reaching the Sadequeda River at its mouth. He traveled along its west branch to settle at what is now the eastern boundary of the Whitesboro Village Green. On the first trip, the party stopped at an abandoned farm and planted corn and potatoes to sustain them through the winter. White cleverly sent the best and largest of his crop back to Middletown to showcase the fertile land, in the hope that others would come and make it their home.

Hugh White was a prominent figure in the development of Whitesboro, Whitestown, and Oneida County. He instilled leadership in his own children, grandchildren, and anyone he associated with. At the formation of Herkimer County in 1791, White was appointed side judge, and he continued to hold that title at the formation of Oneida County in 1798. He and his descendants have been chronicled in many writings, which also note their contributions to the area's progression.

In 1801, White deeded one acre to Oneida County for a site to build a courthouse and jail. The county was authorized by New York State in 1803 to hold court in Rome and Whitesboro and, by an act in 1806, was authorized to raise $4,000 to build a courthouse in Rome and one in Whitesboro. The Whitesboro building stands today, on the Village Green, as the town hall. It served as a courthouse for nearly 50 years, until the courts were moved to Utica. The property reverted to the heirs of White until his grandson Philo White re-donated the site to the Town of Whitestown and the Village of Whitesboro. White, wanting to live in peace with his neighbors, treated the Indians fairly and kindly. The Indians were invited to the Village Green for food and exercise; according to Pomeroy Jones, they amused themselves in wrestling matches.

The Village of Whitesboro celebrated its bicentennial in 2013 on the Village Green. The pioneer spirit that brought founder Hugh White into the wilderness to lay the groundwork for what residents enjoy today was not forgotten. His vision started with a new fertile land where he would establish a home for his family, a church to keep his faith (the first service took place in a barn), a school to educate his children, a court to keep the law (the historic Whitesboro Town Hall), and a cemetery (Grand View) to be his final resting place. These values and institutions are still cherished today. The bicentennial celebration included music from the Whitesboro school band, prayers by participating village churches, and oratory by local dignitaries. The fellowship and friendship experienced that day would have made the village's benefactor proud. Just as the Erie Canal made it possible to ship the goods produced in the village across New York State and to other countries, the village continues to reinvent itself to adjust to the demands of life today.

One

SCHOOLS AND LIBRARIES

Built around 1790, the first schoolhouse was a log structure near where the Whitesboro Town Hall now stands. Later, a brick schoolhouse stood near the former engine house on Moseley Street. The Whitestown (Whitesboro) Academy, founded in 1813, was a private school supported by private fees. In 1835, when enrollment reached 261 (203 boys and 58 girls), parents paid $6 per term for sons and $3.50 for daughters. Students at the academy were mostly between 12 and 20 years old. In 1827, the Oneida Institute was established, later called Whitestown Seminary (1844). The church-backed school was established by the Presbyterians in 1827 to prepare young men for the ministry. It enrolled 550 students in the middle of 1850. It was a tough, no-nonsense school where the day began at 4:00 in the morning with work in the fields in summer and in a factory in winter, making pails, buckets, and farm tools. The students would do classes and then work again until the evening meal. Rev. Beriah Green, the abolitionist, was the principal. It graduated 2,000 young men who became clergymen and missionaries in all parts of the world.

In 1858, Whitesboro residents taxed themselves $6,000 to erect the two-story wooden building that served for almost 60 years and was known as the "Old Green School." Formally named the Union Free School District of Whitesboro, it had a staff of three (a principal and two teachers). The "Old Green" served in this capacity until it was torn down. In 1919, the Main Street School was erected. It was occupied by both elementary and high school students. With the increased population, it was necessary to build a new high school. Between 1936 and 1938, the Whitesboro Central High School was erected. This school, on Oriskany Boulevard, is now Whitesboro Junior High.

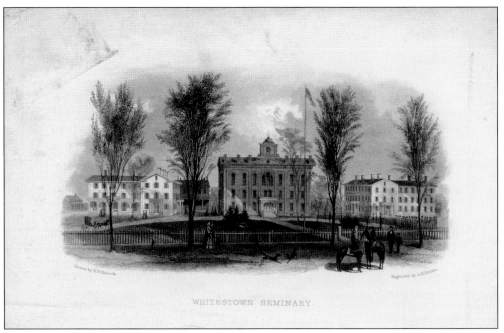

WHITESTOWN SEMINARY.

The Whitestown Seminary, previously known as Oneida Academy and Oneida Institute, was a Presbyterian educational institution based in Whitestown, New York, and founded in 1827. Originally a manual labor college, as Oneida Institute, it was presided over by the abolitionist firebrand Beriah Green from 1833 to 1844 and admitted African American students. Under Green, the school's focus was on preparing young followers of Charles Finney to become missionaries in the west. In 1844, it was sold to the Freewill Baptists because of financial problems, and it became the Whitestown Seminary.

The first public school in Whitesboro was built in 1858. Familiarly known as the "Old Green School," this two-story wooden structure served the residents for 69 years. It was torn down between 1917 and 1920. Main Street School was erected on the same site.

10

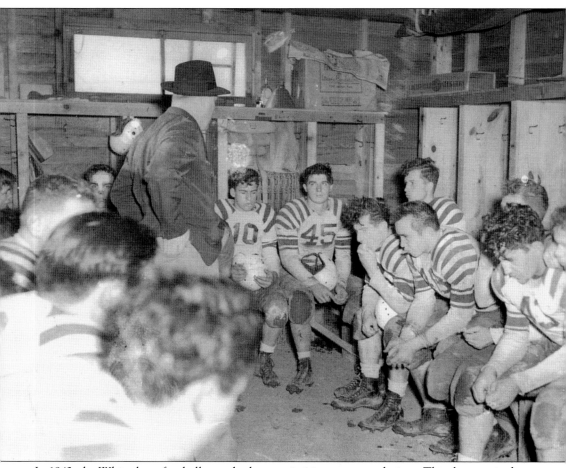

In 1942, the Whitesboro football team had very primitive accommodations. The players suited up at the high school (now the middle school) and ran down Oriskany Boulevard as a team about a mile to Coopers Field in Yorkville to practice. Coach Allan Frye would follow them in his car to make sure they kept pace. Among the players pictured here are Cal "Cog" Rohman, Harold Head, R. Service, W. Emery, and R. Wengert. The boys in blue and white won five of the seven games they played. The result of such a successful season was a three-way tie in the Upper Mohawk Valley League with Canastota and Clinton.

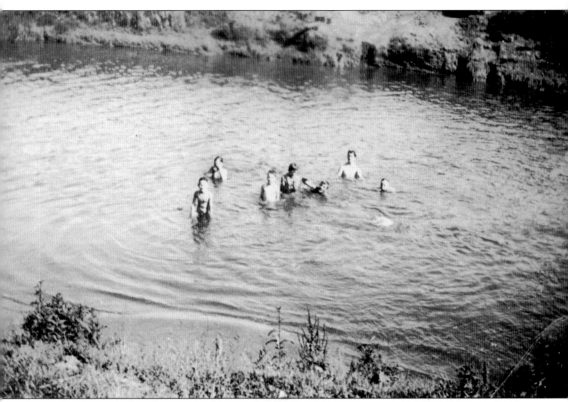

On hot summer days, boys went down to the Mohawk River to swim. Parents discouraged this, as sewage was deposited in the river. The boys would leave their clothes on the side of the river so as not to come home with wet clothes. Jack Rufferage tells a story about a girl who was mad because she was not allowed to swim in the boys-only spot and hid the pile of clothes. The boys got caught when a parent came to find out why they were late for dinner and chores.

This 1907 photograph shows the Gifford brothers, Leonard, 11, and Malcolm, 5. Malcolm's love of baseball continued as he grew older; he played for the Whitesboro Stars in 1918 and 1919. He was a talented right-handed pitcher who hurled a no-hitter in the Utica Twilight leagues. Malcolm entered Hamilton College in 1920 and played three seasons for the Buff and Blue, later captaining the squad in 1924. He was also an avid bowler.

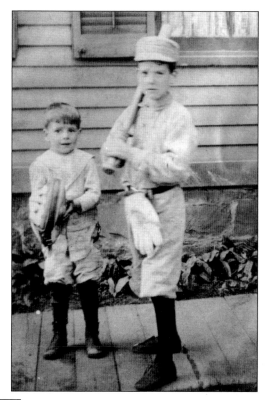

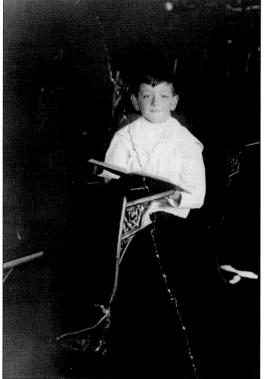

Malcolm Gifford is seated at a school desk equipped with an inkwell for his fountain pen. He was in first grade at the time of this photograph. Due to overcrowding, students had to go to school in the Victory Block, on the corner of Westmoreland and Main Streets. (Courtesy of the Gifford family.)

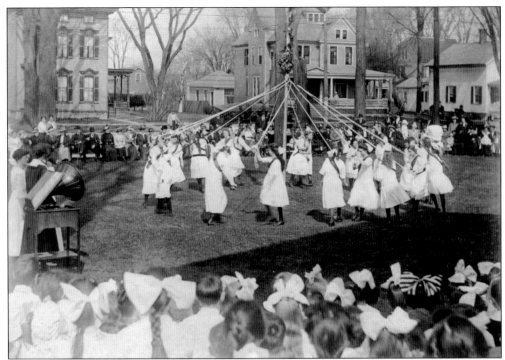

Students celebrate spring with a maypole on the front lawn of the new Whitesboro High School on Main Street in the 1920s. The new Main Street School officially opened in September 1920 with 486 students, grades 1 to 12. The cost to build the school was $110,000. The homes in the background are still there, but the school building now houses apartments.

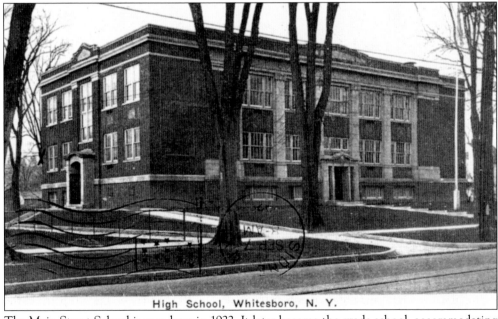

High School, Whitesboro, N. Y.

The Main Street School is seen here in 1922. It later became the grade school, accommodating kindergarten through sixth grades.

Whitesboro Central School centralization took place on May 11, 1936. In 1938, the new high school was built on the south side of the Erie Canal at a cost of $650,000. Curriculum increased to include music, dramatics, debating, home economics, printing, woodworking, and automotive mechanics. That year, the first *Che Ga Quat Ka* yearbook was issued. The building now houses the middle school.

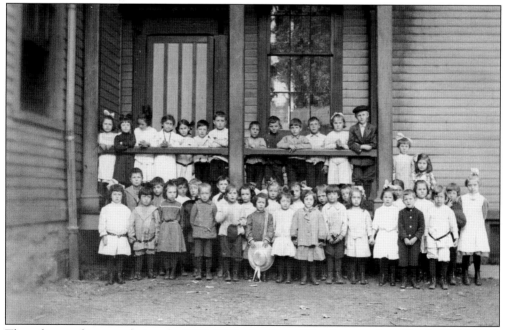

These first graders pose during the 1909–1910 school year. The photographer, Charles H. Hebard, captured many school and village events at the time. The children are on the side porch of the "Old Green School." As evident here, large hair bows were popular in the day. These students were taught by Mary Niver.

This is believed to be one of the first graduation photographs at the new Whitesboro High School on Main Street. As in other class portraits of the time, girls outnumber boys, who were lucky to stay in school past the eighth grade. Boys in more affluent families completed 12 years of schooling, and some would go on to college. Most boys, however, left school after completing the eighth grade to find a job to help support their families.

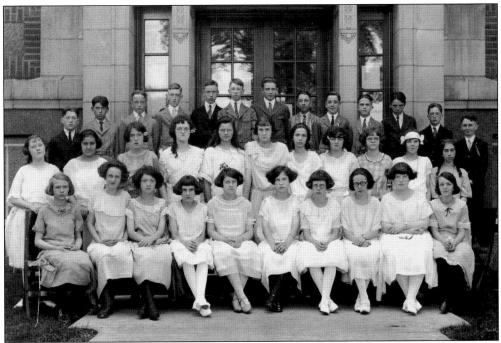

The eight-grade graduating class of Main Street School has gathered here in 1923.

The date of this photograph of an eighth-grade graduation is not known. The boy in the first row, center, is wearing gym shoes. Most children in that day received one pair of shoes at the beginning of the school year. The shoes were made to last by putting cardboard on the inside when the sole was worn. A shoemaker would also put new heels on until nothing was left to nail to.

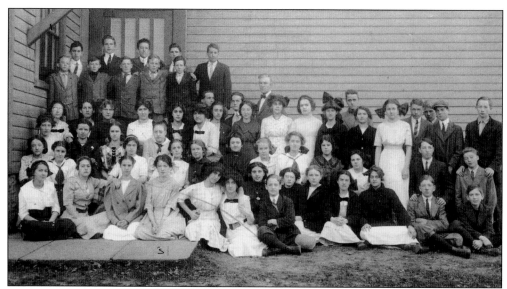

This undated photograph includes Wesley Dimbleby (sixth row, second from left), who later became the fire chief for the City of Utica. His son Jim started the Dimbleby Funeral Home, which is run by his son John and grandson Jim. Also pictured is Charles Voss (third row, third from right), whose family runs Voss's BBQ on Oriskany Boulevard.

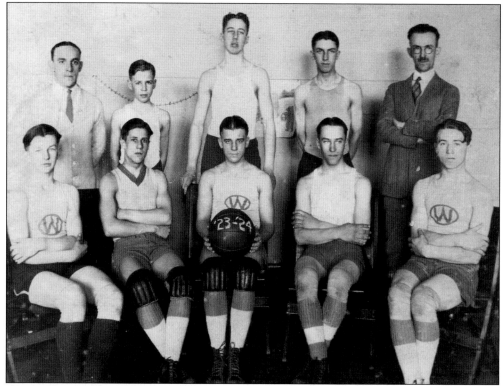

This is the 1923–1924 Whitesboro basketball team. Henry Copperwheat is second from left in the first row. Also pictured are Coach Flagg (second row, far left) and Professor Thompson (second row, far right).

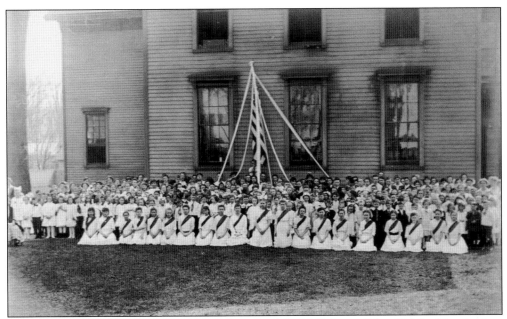

This 1912 photograph shows a maypole on the side of the "Old Green School." All of the children shown here filled up the wing added in 1903 at a cost of $5,000. Improvements at the time included sanitation facilities, running water, drinking fountains in the halls, and electricity. The school's name came from its green paint.

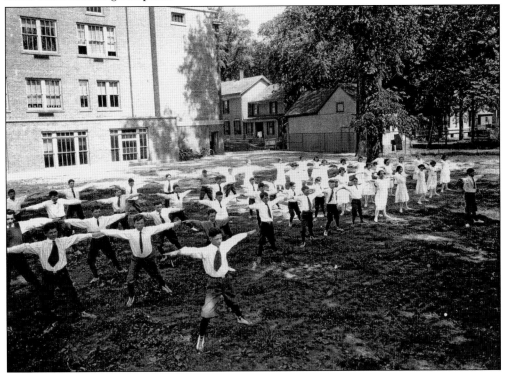

In 1920, when Main Street School was new, recess was a time for exercise in the playground behind the building. It appears that the school instituted a dress code at the time as well.

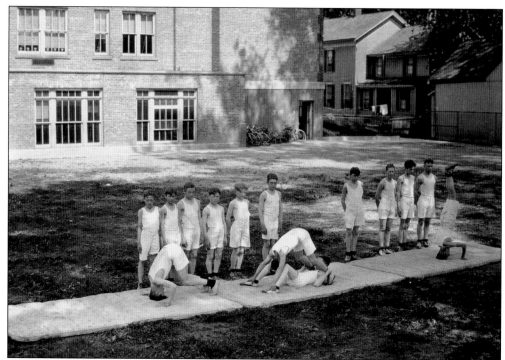

A boys' gym class is conducted behind Main Street School in the 1920s. White uniforms must have been hard to keep clean.

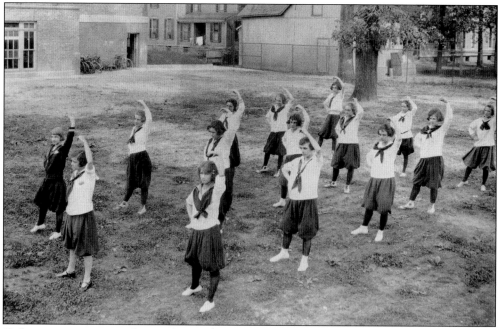

Girls participate in gym class in the 1920s at Main Street School. This was the class of longtime resident Gertrude Zeiter Barry. She remembered the uniforms of pantaloons; girls did not wear pants at the time. Bathing suits were similar to the outfits shown here, including high-knit stockings that got very heavy when wet.

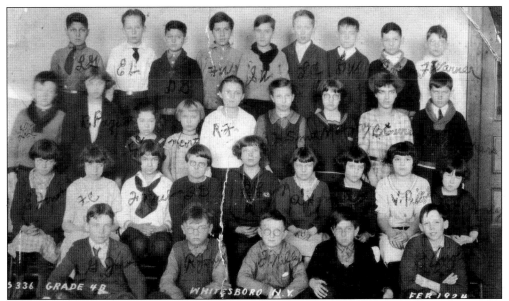

This is a fourth-grade class in 1924. Someone has written initials to identify the kids, as well as a couple of last names.

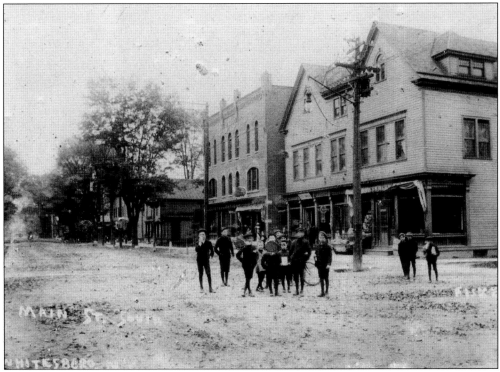

Children enjoy recess in the middle of Main Street at the corner of Westmoreland and Railroad Streets. After serving many decades, the wooden "Old Green School" in the next block was torn down. In 1920, the brick Main Street School was opened on the site. During construction, school was held in many places around the village. The building on the corner was the Victory Block, where classes were held on the second floor.

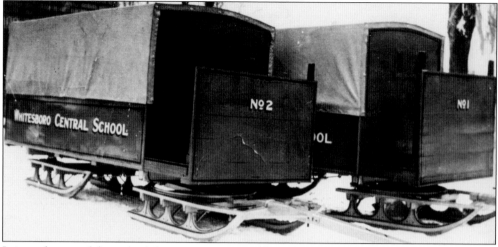

It is not known if these sleigh buses were ever used by Whitesboro School. This photograph was displayed in the Manna Liquor store in the Whitestown Plaza, but its history is a mystery. The buses are parked in front of C.P. Maloney's blacksmith shop on Railroad Street, now Linwood Place. School centralization took place on May 11, 1936; the sleighs are labeled "Whitesboro Central School." The buses may have been used in a parade or other activity and may not have served as student transportation. (Courtesy of Peter Manna.)

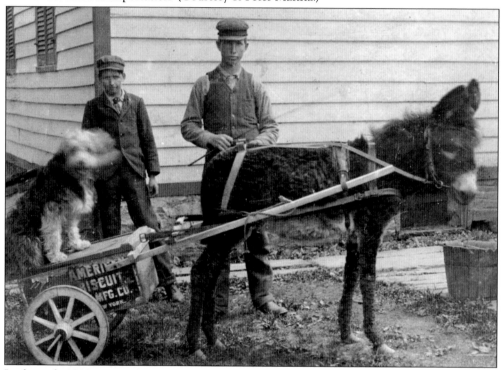

In the early 1900s, many toys were made from wooden boxes acquired from grocery stores. They were made into soapbox derby cars, scooters, and wagons or carts, like the one shown here. This cart is made from a box of the American Biscuit & Manufacturing Co. In 1898, after a merger, the company became National Biscuit Co., later known as Nabisco. The photograph was found in a barn on Moseley Street in Whitesboro, but the boys' identities are not known.

This architectural drawing by A.F. Gilbert & Son shows the future Hart's Hill School addition. This is the only picture in the Whitesboro Historical Society's collection of this school as it stood prior to its current configuration; it was obtained from the Whitesboro Alumni Association. In personal interviews, former students remember the two-room schoolhouse (left). The new school was constructed around the two-room original building. Classes continued during construction. The addition was completed in 1953.

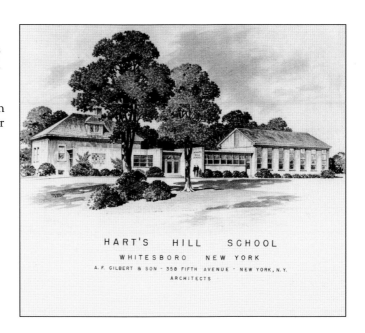

HART'S HILL SCHOOL

WHITESBORO NEW YORK

A. F. GILBERT & SON · 358 FIFTH AVENUE · NEW YORK, N.Y.
ARCHITECTS

The members of John Siedsma's eighth-grade graduating class pose in 1911. Shown here are, from left to right, (seated) Ed Overocker, Mae Connors (teacher), and Frank Burns; (standing) John Siedsma, Daniel Schultz, and William Grice. The spellings are believed to be correct; the names, written on the back of this photograph, are quite faded. (Courtesy of Betty Krol Siedsma.)

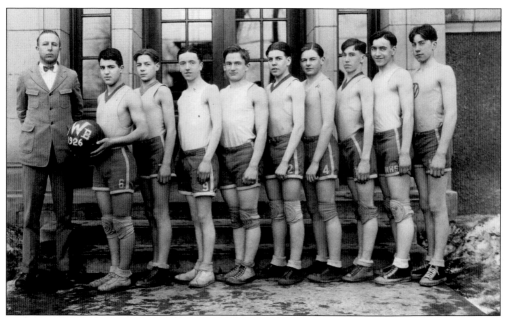

The 1926 Whitesboro basketball team poses outside Main Street High School. The snow banks on both sides of the path mean these players must have been cold as they took this portrait. No names appear on the photograph, and the coach looks as young as the students.

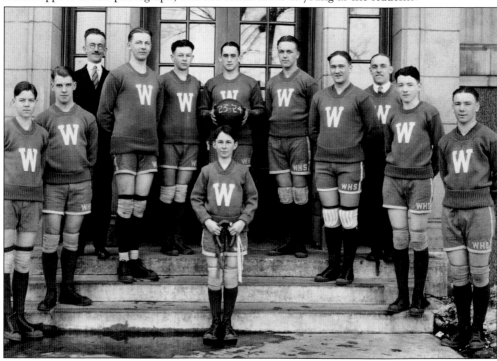

The 1923–1924 basketball team gathers on the front steps of the school. This may be the varsity team. Unlike in the previous photograph, taken at a later date, the athletic shoes and uniforms of the players shown here are matching and look very professional. The younger boy holding the horseshoe for good luck may have been the water boy.

This photograph of a student body is undated, and no names are available. The only notation indicates that it was taken by Cunningham's Photographers of Commerce of Utica, New York. The girls in the matching dresses may have been part of a choral group. In the background are the beautiful oak trees that lined Main Street until they were hit with Dutch elm disease. In the late 1940s and 1950s, crews came around in a truck, spraying chemicals on the trees to try to save them. Residents were told to stay inside until the spraying was completed.

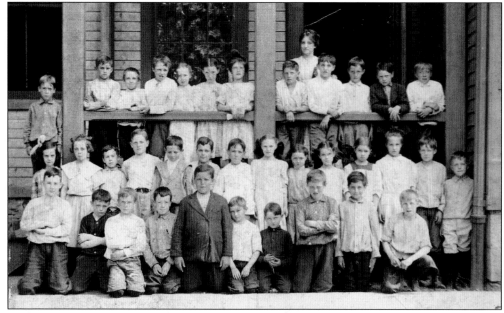

Gladys Carr's fourth-grade class of 36 students poses here in May 1911. Pictured here are, from left to right, the following: (first row) Lester Ferguson, Osborne Jones, John Smith, Thomas Carey, Samuel Parkett, Claude Brierley, Stuart Barker, Gilbert Barker, Stuart Darling, and Stuart Wilson; (second row) Hazel Rahn, Agnes Carroll, Clayton Evans, Harold Michael, Stuart Kellogg, Byron Kast, Thomas Mara, Elizabeth Selback, Minnie McCarthy, Norma Tyler, Doris Purdy, Agnes Warner, Stuart Welch, and Mack Place; (third row) Ward Phelps, Charles Williamson, Louis Phelps, Frank Tobin, Susie Wind, Margaretta Cassidy, Lenore Newell John Newell, Miss Gladys Carr (teacher), Harold Besig, Ernest Wilkinson, Dennis McCarthy, and Percy White.

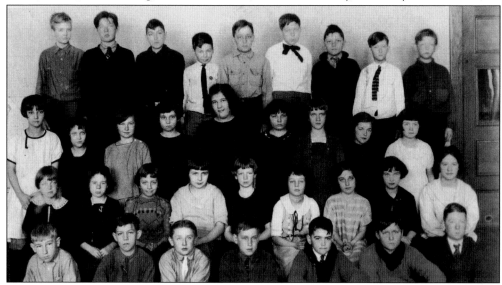

The only information on this photograph indicates grade 4A, in Whitesboro, New York, and that it was taken in February 1924. The students look so serious; it has been told that, on many days, it was very cold in the building. The village children pictured here became close friends, both during and after school.

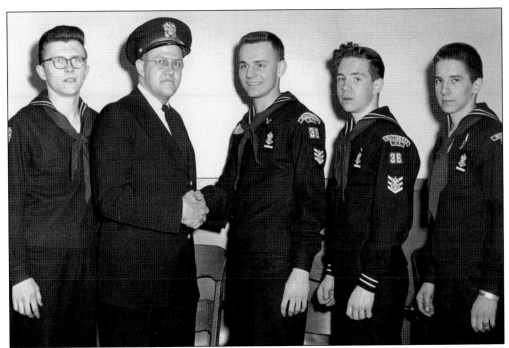

Whitesboro had a number of Scout troops. Here, an Explorer Scout is congratulated by Scout leader Ed Jones for being chosen to go to the National Scout Ranch in New Mexico. Pictured here are, from left to right, James Bowen, Ed Jones, Tom Clark, Joe Hague, and an unidentified boy.

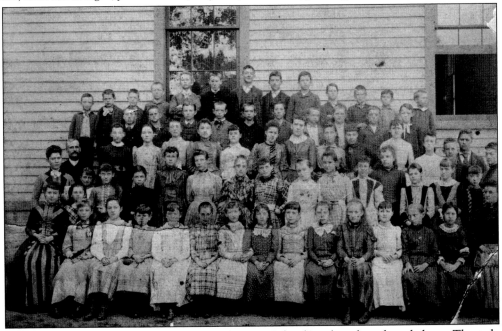

In 1890, the entire student body of the "Old Green School" gathered on the side lawn. The only student mentioned on the back is Anna Gifford Jeffries. The writing is not clear, and the spelling may be incorrect. The girls had to walk to school in their long dresses, at a time when paths and roads consisted of dirt.

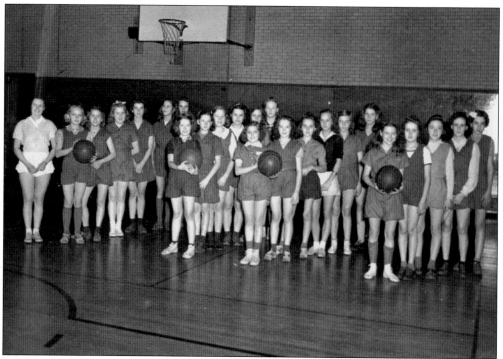

Members of the Girls Athletic Association pose in 1947. On the far left is the teacher, Kay Lathem Wade. The tall girl in the very back center is Nancy Vincent. (Courtesy of Marian Vincent.)

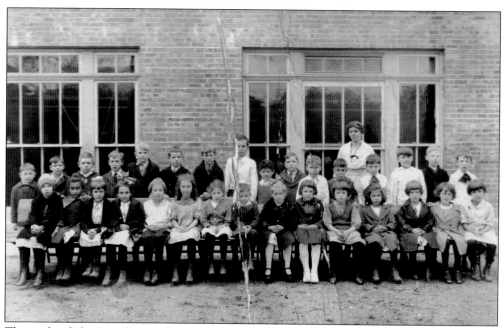

This undated photograph was taken at the "new" high school on Main Street, built in 1920. Many of the girls are sporting the short "Dutch boy" hairstyle of the day.

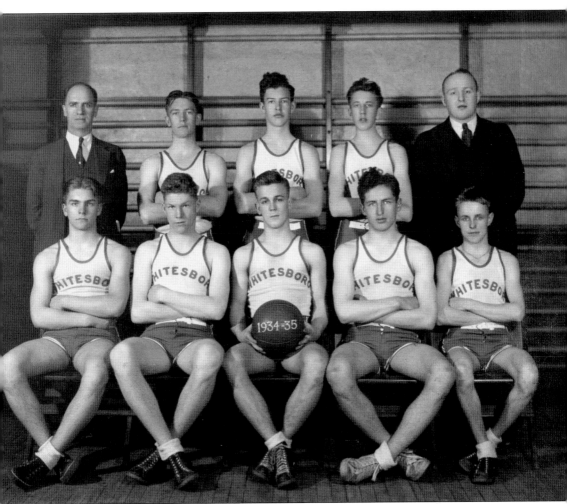

The 1934–1935 Whitesboro basketball team poses here, along with a very young coach Allen G. Frye. Shown here are, from left to right, (first row) Walter Christ, Arthur Phillips, Harold Moore, Sidney Vanderland, and August Zick; (second row) Prof. Preston H. Martin, Lawrence Britt, Leon Cary, Edward Kocyba, and Frye. Coach Frye was the physical education teacher from 1931 to 1968. The football field behind the current middle school on Oriskany Boulevard is named in his memory.

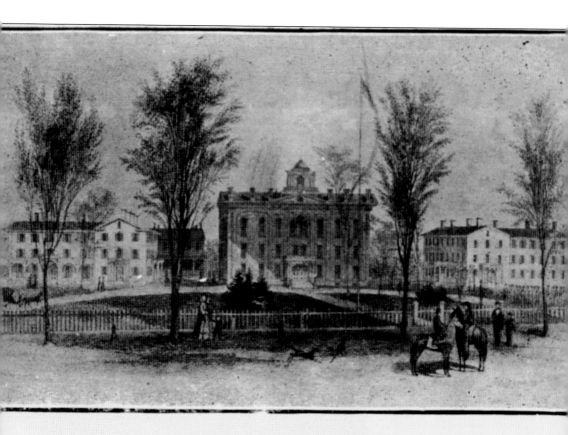

Whitestown Seminary

The Oneida Institute in Whitesboro combined manual labor with studies to train poor young men for the ministry. This school was the first institution of higher learning in the country to admit African American students, including Henry Highland Garnet, a leader in the abolition movement.

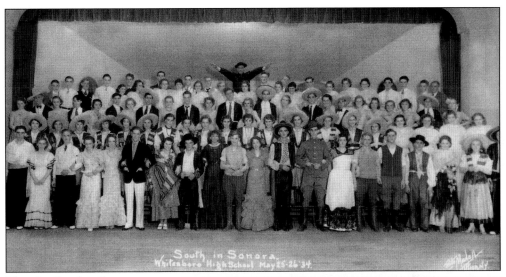

The play *South in Sonora* was performed by the students of Whitesboro High School on May 25–26, 1934. The photograph includes the label "Photo Madell, Utica, NY." This photograph was purchased by a historical society member for a couple of dollars, and what a find it is! The students went all-out with the costumes, probably raiding closets of grandparents at home, during a time when many generations lived under the same roof. (Courtesy of Joe Petronella.)

Lucia A. Kelly was the first librarian of the Dunham Public Library. The Dunham family donated the home of their parents, Dr. and Mrs. Moses Earl Dunham, to the school system for a library. Dr. Dunham was the minister of Whitesboro Presbyterian Church.

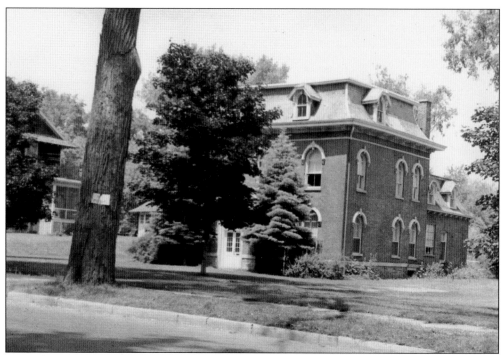

Dr. and Mrs. Moses Earl Dunham's home on Main Street is now the Dunham Public Library.

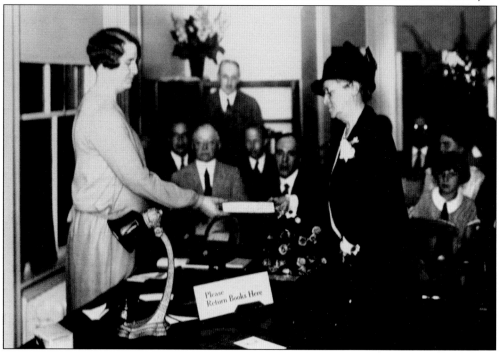

Lucia A. Kelly (left) and Helen Dunham (right) are seen at the opening of Dunham Public Library on August 26, 1927. Those seated, not identified, may have been on the board or were village residents attending the opening. It was common for people to dress up for public occasions. The photograph was taken by William J. Helmke.

This is a present-day view of the Dunham Public Library.

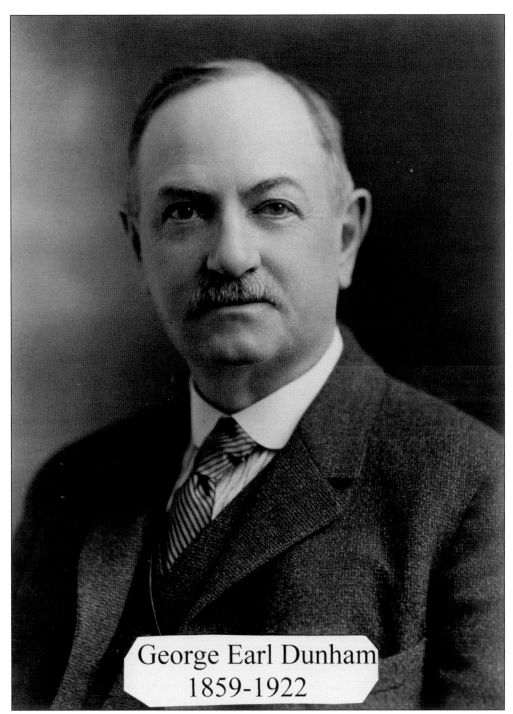

George Earl Dunham
1859-1922

George Earl Dunham (1859–1922) attended Whitestown Seminary and received a degree from Hamilton College. He was admitted to the Oneida bar and, in 1886, was named editor-in-chief and president of the Utica Daily Press Publishing Co. He continued in this role until his death. He donated the home of his father, Rev. Moses Dunham, for the Dunham Public Library, a very popular fixture in Whitesboro to this day.

Two

BUSINESSES AND FARMS

Fertile land to farm, an abundance of water, and the promise of a better life for his family brought Hugh White to this wilderness. In 1783, on his first trip to what became Whitestown, he planted crops along the Mohawk River and sent the best of the harvest of corn and other vegetables back to Connecticut to encourage his neighbors to settle in his new home. The first business in Whitesboro was a gristmill that Hugh White built on the Sauquoit Creek.

Many changes have taken place in the area, altering the way business is done. The Erie Canal made commerce in the village prosper. National retail stores put mom-and-pop establishments out of business. The cotton mills moved south for economic reasons, and the changes the thruway made by dividing many farms along its path were devastating for many family-run businesses. Farmers markets in the Village Green bring fresh fruits and vegetables to residents' tables. Walking and biking along the Erie Canal (Barge Canal) path reminds people of the river that brought Hugh White to the village.

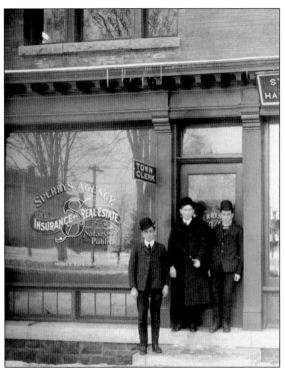

Sperry's Agency dealt in insurance and real estate, and it also included a notary public and town clerk. This photograph was taken in Whitesboro around 1929. This business was located in the Wind Block, previously the Symond's Block, on Main Street between Moseley and Westmoreland Street. Upstairs in the building was a big hall where basketball was played and minstrel shows were performed. A tearoom for the ladies and a lunchroom for the gentlemen were also there. Sperry, his son Charles, and another agent are in front of the building. (Courtesy of Burton Sperry.)

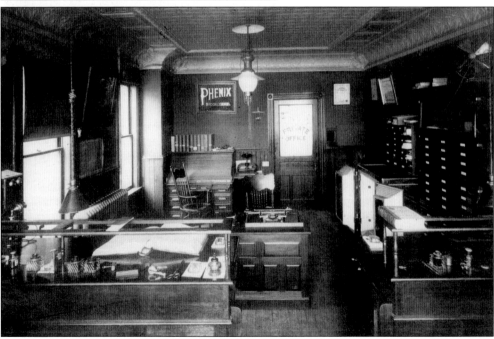

This is the interior of the Sperry and Son Fire Underwriters, Real Estate, and Money Brokers. In the background is a Quigley rolltop desk. Note the tin ceiling. A sign for Phoenix of Brooklyn, New York, can be seen on the back wall. Sperry and Son advertised in 1908 that they were leaders in real estate, responsible for all property sold in the last five years in Whitesboro, and were fire insurance specialists. (Courtesy of Burton Sperry.)

David E. Ellmore (1880–1945) was the fire chief from 1922 to 1942 and was president of the Babbitt Hose Company from 1904 until his death. He was also president of Oneida County Active and Exempt Fireman's Association from 1912 to 1939. His office was in his home. Ellmore was associated with Mid-State Builders, Inc., as superintendent. He was widely known throughout the state for his legal abilities. He served as judicial clerk in Albany for 38 years. It is not known if this photograph was taken at his home or in Albany. He kept a full set of law books at both locations.

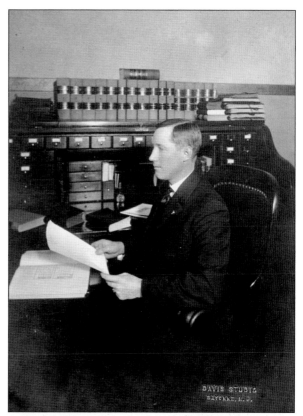

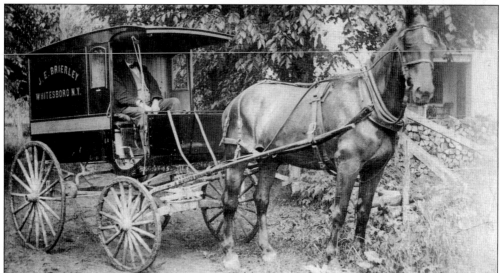

J.E. Brierley was an early medicine man who traveled the valley with his horse and wagon, dispensing tonics and remedies made from healthful herbs, roots, and barks. He charged $1 per bottle for the medicine, made in the laboratory of Honadogo Medicine Co. in Whitesboro. The Brierley Farm was at the intersection of Watkins Street and the Erie Canal, where the New York State Thruway crosses over today. One of the tonics found in his book of recipes was called "Grandfather's Great Herb Blood Remedy." (Courtesy of Carol Bowen Curtacci.)

The Whitesboro Canning Factory (The Beanery) stood on the southwest corner of Watkins Street and the Erie Canal. The long wooden building later became the cheese factory. Standing at center is a Mrs. Evans. A Mr. Evans is leaning over her. Many village children picked beans at the Thomas Farm on Main Street and on the flats when school was out for the summer.

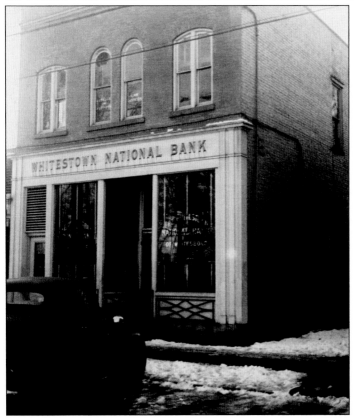

The Whitestown National Bank was built on Main Street, in the block between Clinton and Main Streets, in 1918. Harry Kenyon was president, and F.W. Richards was cashier. It was located in front of the Haynes Feed Store. Fortunately, the brick-constructed bank survived a fire that destroyed the Haynes store. The bank became part of Oneida National Bank & Trust Co. of Utica on July 1, 1944. The new bank was built in the Whitestown Plaza.

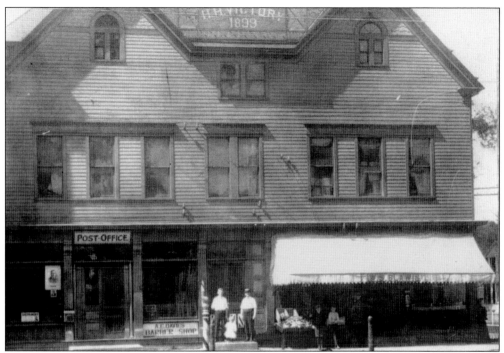

H.H. Victory Block was built in 1899. The post office is on the left, and Art Davies's village barbershop is at center. The striped wooden barber pole is visible in front, and Davies and his little girl Millie pose in the doorway. On the corner of the building, on the Westmoreland Street side, is W.S. Blawis Groceries and Provisions, which sold high-grade teas, coffees, canned goods, fruits, vegetables, oysters, and clams in season.

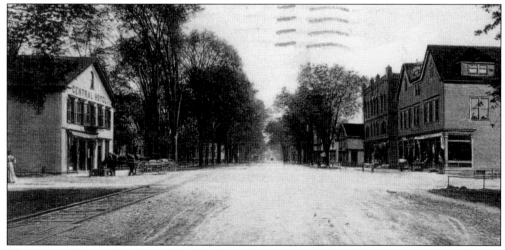

This postcard shows the Center Hotel (left) on the corner of Railroad Street (now Linwood Place) and Main Street. It was run by Henry J. Moehle. He advertised that the hotel had a "well-stocked bar attached." He charged $1.50 a day for lodging. The people who traveled on the Erie Canal boats could tie up for the night at the dock on Brainard Street and rent a pallet with a mattress upstairs in a community room at the hotel. A hot meal was served downstairs. After long travel on a packet boat with pull-down beds that also served as the table, this was a comfort and gave the travelers a break from the water.

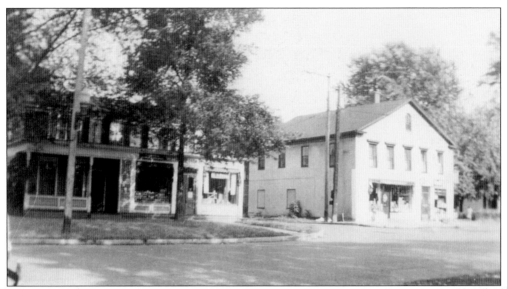

The two stores on the corner of Main and Railroad (now Linwood) Streets supplied everything residents might need to keep their home or business in repair and to put food on the table. On the left is Rutgers Hardware (formerly Andersons), and at right is Murray & Ramsdale (formerly Toussaints) meat market. In the 1940s and 1950s, one could buy two-penny nails out of a barrel and receive instruction on how to use anything sold in the hardware store. At the meat market, customers were known by name, and everything was freshly cut and wrapped in butcher paper. Orders could be called in advance and picked up later.

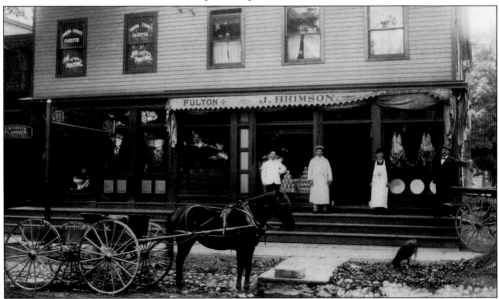

This photograph, taken in 1906, shows the Fulton Block at Main and Moseley Streets. Frank O'Brien, a plumber, and John Brimson, a butcher, occupied the first floor. Whitestown Printing Co. ("A House of Cleaver Printing") occupied the second floor. The building later became the B&D (Bliss bowling alleys and restaurant), then the Sea Fare. The Village Barber Shop and offices with apartments were upstairs. On January 13, 2012, a fire caused by a faulty freezer on the upstairs porch destroyed the building.

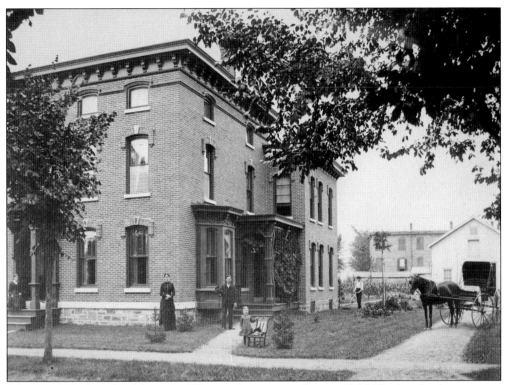

John Brimson's large brick home on Pleasant Street is seen here in 1906. The butcher business was good for the family, as is evident from this beautiful home. A man mows the grass with a push-mower, the latest craze at the time. Many families grew their own vegetables and raised chickens to supply fresh eggs. A little girl with her doll stands next to a chair in front of the house. Only well-to-do families owned such nice horses and buggies. The house remains, but, like many old, beautiful homes, it has been converted into apartments.

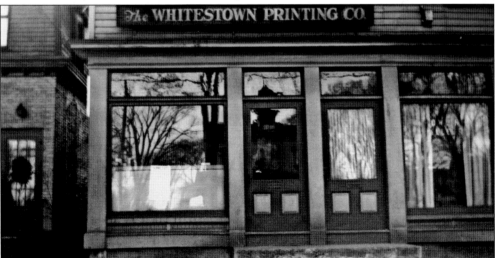

The Whitestown Printing Company took over the butcher and plumbing shops. Business must have increased for the printing company for it to move from upstairs to occupy the entire street level.

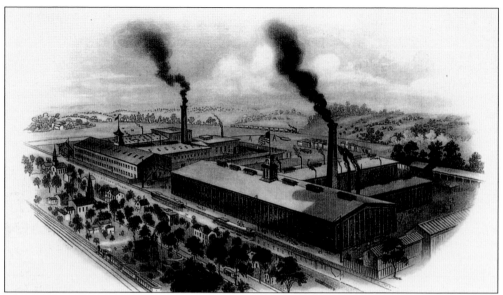

This lithograph of B.T. Babbitt Machine & Iron Works shows its location on the Erie Canal. A canal boat and train from the New York Central & Hudson River Line can be seen in front of the building. The factory opened around 1870. Babbitt, called the "soap king," made money on his invention, the Babbo cleanser. He held many patents, including for an independent expansion steam generator; a better steam boiler hot blast; and ordinary draft heaters for locomotives. Babbitt loved horses; it is said that his prized horse was poisoned, so he had a taxidermist stuff it and put it in his factory to remind others of the crime. Later, the building was home to the Utica Casket Company.

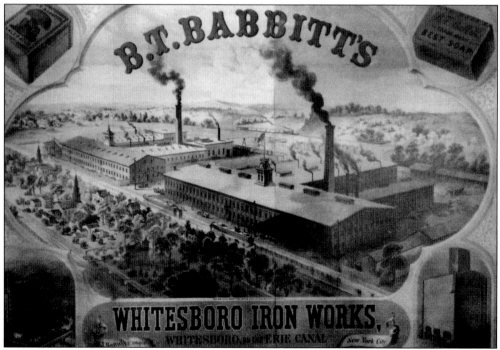

This postcard advertised, "For the laundry or bath, try B.T. Babbitt's 99 soap."

The Sills-Babbitt House, at 136 Main Street, next to the Presbyterian church, was built in the early 1800s as a home for Theodore Sill, a general in the War of 1812. Sill, a member of the New York State Assembly from 1814 to 1826, once declined the Republican nomination for president. The home was purchased by Benjamin T. Babbitt. He established the finest machine shop in the state on the Erie Canal (Byrne Dairy, now on Oriskany Boulevard), where he produced steam engines. He was very supportive of the Whitesboro Fire Department and built the first fire-hose cart and donated it to the fire company. The department named two divisions of its volunteer firemen, the Hook & Ladder Company and the Babbitt Hose Company, in appreciation of his generosity.

Pictured is the Quigley Furniture Company, established in 1847. In 1918, a *Utica Tribune* headline read, "The Quigley Furniture Company manufactures office furniture of every description, office desk of real quality." Quigley was famous for the big oak rolltop desks that can still be found in antiques shops. Most of the craftsmen were German immigrants who used their talents to carve intricate designs into the furniture. The last Utica directory listing for the company was in 1959, when a scaled-down Quigley was sold to a discount furniture store, now a bottle reclamation center.

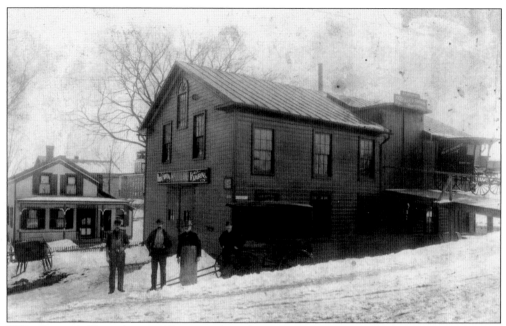

W.R. Coogan's Horseshoeing Shop stood on the corner of Westmoreland Street and the Erie Canal. The sign advertises horseshoeing and repair. In the back of the building was a ramp and dock, where people could have their horses that pulled the boats on the Erie Canal reshod.

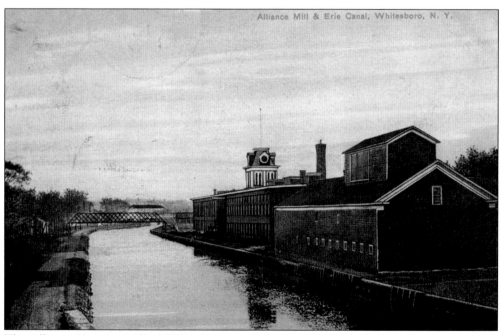

The Alliance Knitting Mill of Whitesboro was the maker of a line of ladies' vests, pants, union suits, and corset covers. It also produced two-piece garments and union suits for children, boasting that every garment had a special feature, like the corset cover with a safety pocket to hide valuables. At this location today are the Whitesboro Fire Department and the Byrne Dairy.

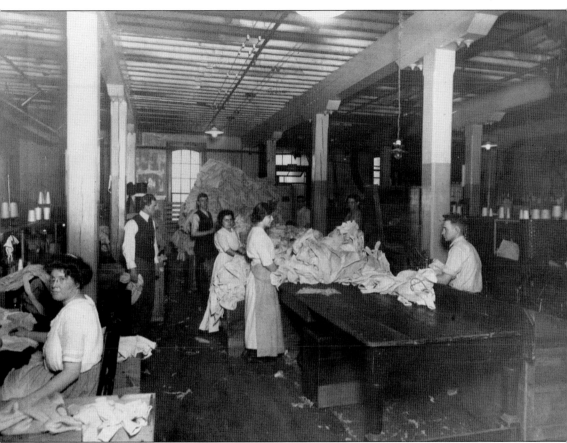

The Anchor Knitting Mill was started in 1915 by Robert Ablett. It manufactured knit underwear, outerwear, and athletic wear. The mill was in the brick building that was once part of the Oneida Institute. It is not known if this is the brick building behind the funeral home on the property today. Pictured here are Earl Green (foreman), Frank Gardner, Frank Flo, Stewart Darling, Jack Whys, Winifred Visser, Nellie Joslin, and Milinda Campby. Upon the Abletts' deaths, the property was left in a trust to the Baptist Church for village use. When the endowment ran out, the property was sold off in parcels to the people whose land bordered it.

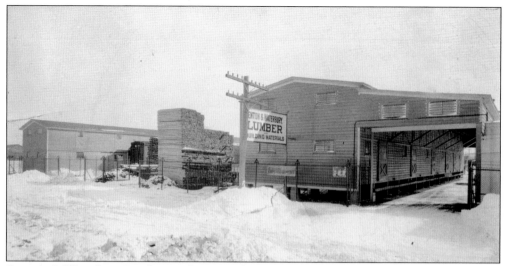

Denton & Waterbury Lumber Yard was on the corner of Clinton Street and the Erie Canal. The offices, store, and large storage sheds occupied the entire block that is now the Colonial Shopping Plaza. The Utica Rome Railroad Line went up the back of the property, and the canal was in the front. Customers could buy everything they needed to build a house. An early catalog of the company had different models of homes to choose from and a product list of needed materials. The company was bought out by Woodbury Lumber Company. (Courtesy of Nancy and Don Hartman.)

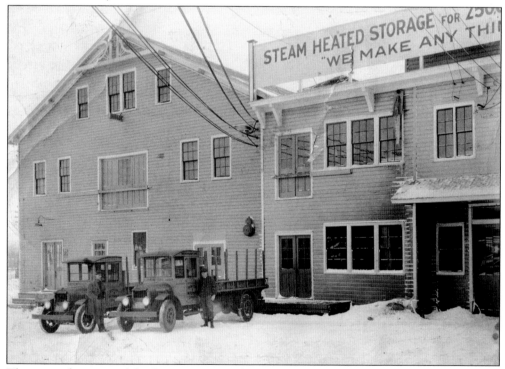

This is another view of the Denton & Waterbury Lumber Yard. Because of the snow, it would have had to ship the lumber by train or make truck deliveries locally. (Courtesy of Nancy and Don Hartman.)

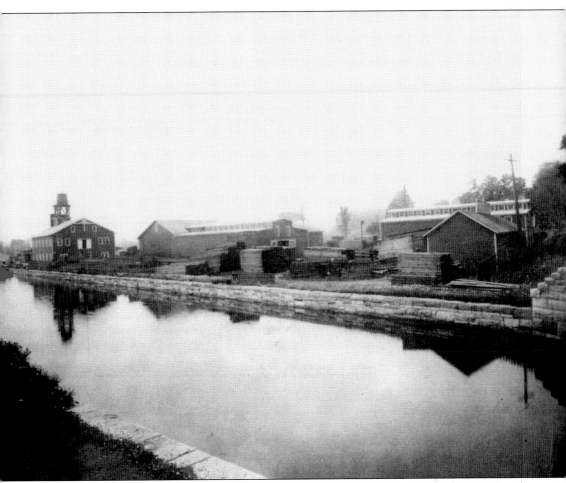

Denton & Waterbury Lumber Yard is seen from the Clinton Street Bridge over the Erie Canal around 1900. A canal boat is tied up to receive a load of lumber. The stone wall remained many years after the canal was filled in, and Oriskany Boulevard was built in its place. The wall was a favorite place for kids who walked to the high school in the next block. (Courtesy of Jim Ashton.)

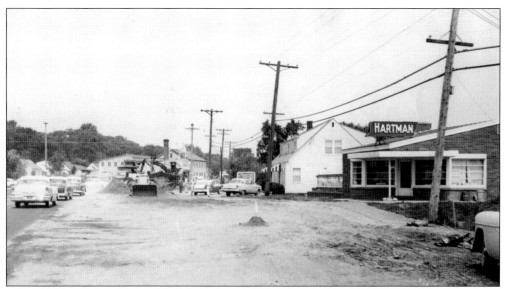

The Hartman flower shop and greenhouse was across the street from Whitesboro High School (the middle school today). It was a family-run business and served as the florist for many families in the village for years. A Mrs. Hartman knew everyone by name and took special care with orders. Many teenage girls got their first courage for a school prom from Hartman's and had their wedding flowers done there. Don Hartman grew up in the business. He and his wife, Nancy, run the Hartman's Potting Shed Antique Shop in the building today. In front of the building, construction is under way to make Oriskany Boulevard a four-lane road. (Courtesy of Don and Nancy Hartman.)

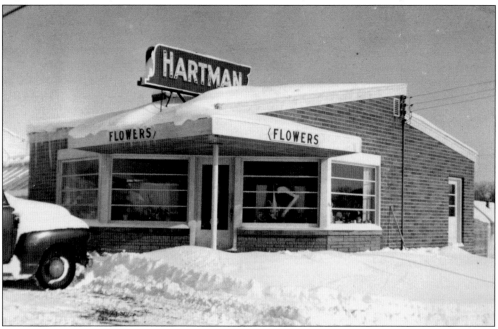

A closer look at the front of the Hartman flower shop shows the window displays from which customers could choose arrangements. It was fun to go into the shop and see all the beautiful live flowers in the cooler behind the counter. Customers could go in the back and watch workers making arrangements to fill orders. (Courtesy of Don and Nancy Hartman.)

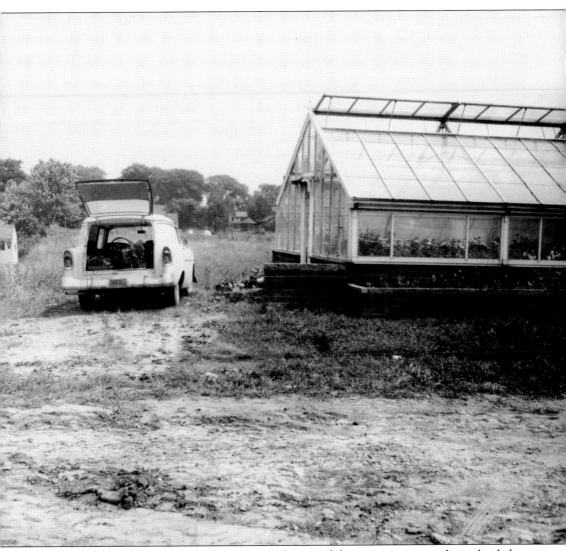

In this photograph of the greenhouse, it is not known if the station wagon is being loaded or unloaded. Visible are potted geraniums in the greenhouse that probably were going to the cemeteries for Decoration Day—today's Memorial Day. (Courtesy of Don and Nancy Hartman.)

The Frank Symonds Building became the Wind Block after Wybo Wind purchased it. From the center stairs, one could reach the third floor, which had a basketball court. On special nights, dances were held on the court. J.E. Brierley, who did his burlesque shows on the stage, carried all of his props and chairs up three flights of stairs for the production. On the way up, visitors could stop for refreshments on the second floor, which had a café for men and a tearoom for women.

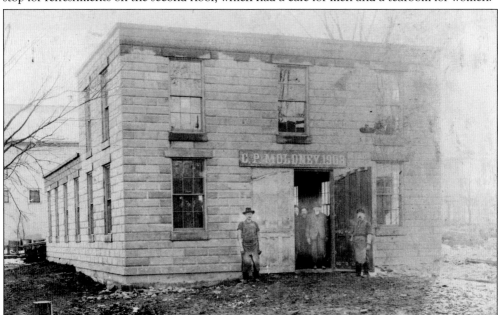

Cornelius P. Maloney opened his concrete blacksmith and general repair shop on Railroad Street in the fall of 1908. Pictured are, from left to right, three unidentified, Milo Loomis, and Maloney. The building was behind the home of the Mara family, who owned Mara & Midlam Fuel Company, the coal yards next to the train station. The cement block remains, and the Mara family house is now the office of dentist John Konyak.

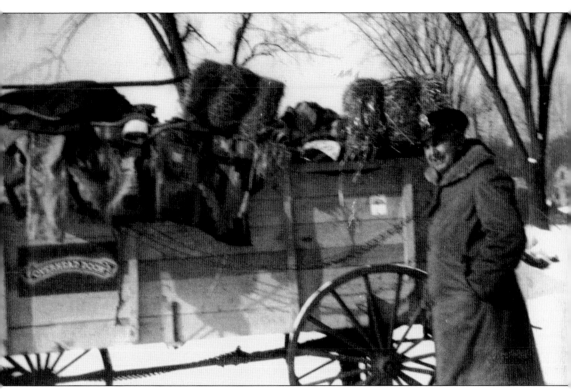

On this cart, parked on Oriskany Boulevard, a sign reads "overhead door." The cart appears to be in the driveway between Oriskany Boulevard and Powell Avenue. Standing next to the cart is police chief Frank Tobin. The highway garage was behind the overhead door building. A fire broke out in one of the storage sheds. The Whitesboro Fire Department holds its barbecue pit in this spot today.

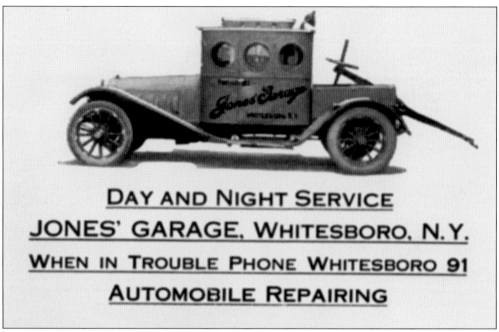

DAY AND NIGHT SERVICE
JONES' GARAGE, WHITESBORO, N.Y.
WHEN IN TROUBLE PHONE WHITESBORO 91
AUTOMOBILE REPAIRING

This vehicle, a Lozier touring car, was converted into a tow car at F.X. Cronk automotive garage in Utica. Arthur A. Jones, a mechanic at the garage, bought the tow car and moved to Whitesboro to open his own garage. The first Jones Garage, Whitesboro's oldest garage, was on Moseley Street, in a building that later became Bliss Bowling Alley. He later moved his business to 14 Clinton Street, operating there for many years.

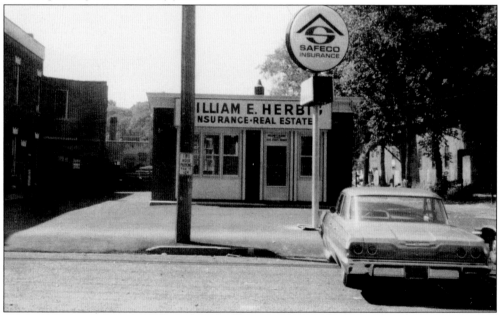

Formerly a gas station, this insurance and real estate office stood next to the Winds Bakery at 107 Main Street. The Chevy parked at the curb is a 1955 or 1957 model. William E. Herbig owned the building at the time. Today, this site is the entrance to the Buck Apartments building. The photograph was taken in 1969 or 1970.

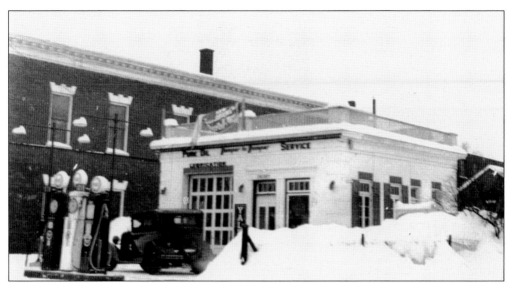

This is the building shown in the previous photograph when it was a gas station. It was unusual to see a service station in the middle of a business block. (Courtesy of Jim Service.)

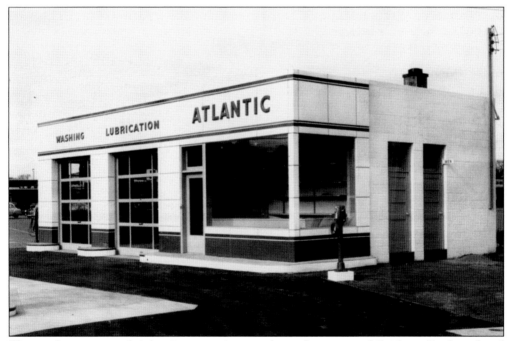

The newly constructed Atlantic gas station stands on the corner of Oriskany Boulevard and Gardner Street in 1954, next to the new Whitestown Shopping Plaza, the first strip mall in the area. An island built when the boulevard was turned into a four-lane highway made it difficult for gas station patrons to get into the station. In 1961, the owner sold the gas station to Jean's Beans, a takeout store for fish fries and baked beans. A new Atlantic station was built on the corner of Clinton Street and Oriskany Boulevard.

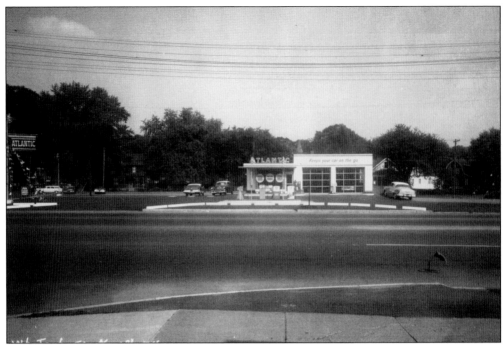

The Atlantic gas station is seen at its new spot on Clinton Street and Oriskany Boulevard. This location was more accessible to drivers in the heavy traffic flow in the area. The Colonial-style Adirondack Bank is located here today.

Marty's Food Market is seen here on the corner of Main and Westmoreland Streets in the 1940s. The store settled into this spot after previously occupying various locations At one time, the building housed Art's Barber Shop. Then, B.L. Wrench had a funeral home there. On the other side of the building, Dot Worden ran Dotty's Variety Shop in later years. The last business was Joe's Pizza, which was destroyed by a fire that started in an apartment upstairs. This site is now a parking lot for the Wind Block Apartments building.

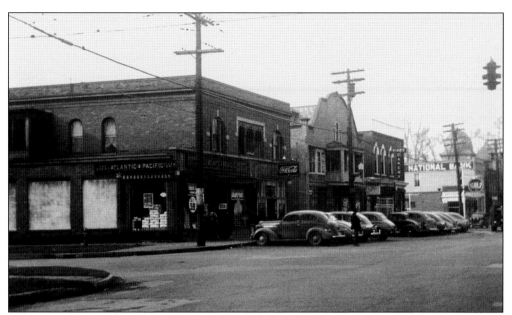

The A&P Grocery Store is seen here in 1939, when it was on the corner of Main and Clinton Streets. The floor was old wooden plank, and customers were greeted with the smell of fresh coffee, ground in the machine at the front of the store. Orders could be called in and delivered. The brick building had apartments upstairs. It has housed a number of businesses since then.

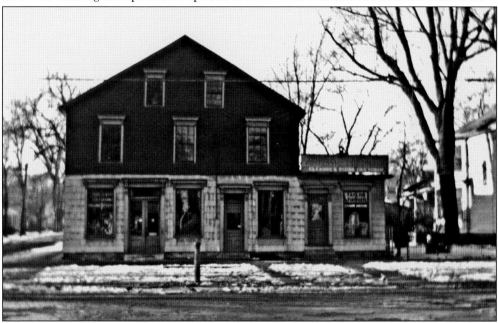

On the corner of Main and Moseley Street was the Kayser Home and Shoe shop. The building is now gone, but a story in D. Gordon Rohman's book *Here's Whitesboro* tells of Henry Kayser as a boy. His first job was pumping the organ for the organist at the Whitesboro Presbyterian Church. He earned 25¢ but was fired when his curiosity got the best of him. He wanted to know what would happen if he slacked off on pumping. The organist was not happy. The parishioners decided that the young Kayser was not taking the task seriously and let him go.

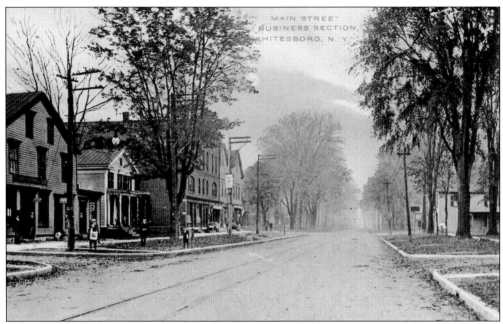

The old building at 155 Main Street is shown here at far left. Its last occupants before it was finally torn down, after being empty for many years, were Mr. and Mrs. Lomax. They and their daughter Shirley Platt ran the Coffee Shop and sold penny candy, cigars, and cigarettes. Residents could pick up a newspaper and grab a cup of coffee on the way to work.

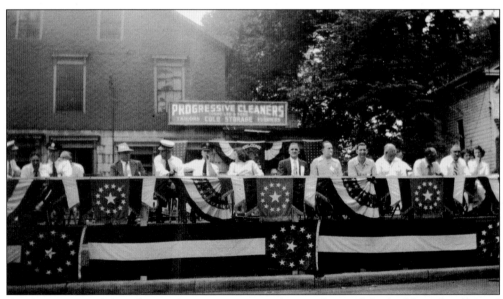

A reviewing stand for a fireman's convention parade is in front of the building that housed Progressive Cleaners. Previously, the store was T. Bernstein, Tailor and Furrier. In an advertisement in the *Whitestown Free Press* in 1931, Bernstein offered to repair or remodel spring or summer clothes, or make a new suit or topcoat to order for $18. He was a member of the Business Men's Association, according to the seal in the advertisement. Bernstein called for customers' work, delivering the finished product to their house.

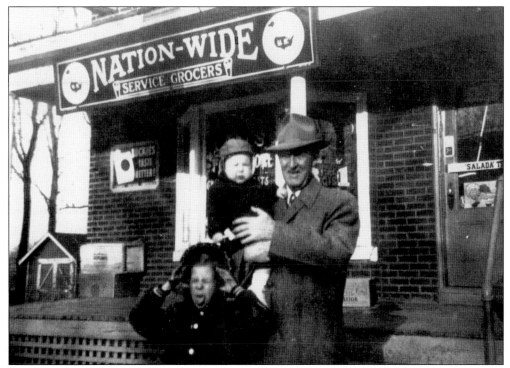

Part of the business aspect of Whitesboro was the family-owned grocery and dry-goods stores that lined Main Street and Oriskany Boulevard. On upper Main Street, across from Palmer Avenue, was Leon Cary's Nation-wide grocery store. It was convenient for people of upper Main Street. They also had Schindler's Grocery Store, another family store on the next block. Here, Leon Cary Sr. and his grandchildren pose in front of his store in 1955.

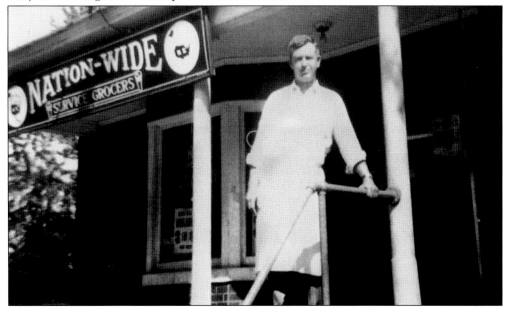

Leon Cary Jr. stands in front of his grocery store at 264 Main Street. Families often lived in the same building as their store, which made it difficult to close on time.

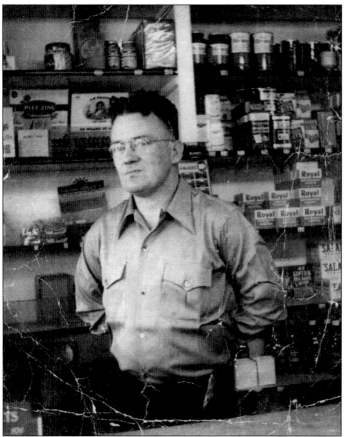

Another family-owned store was Charles Bowen's on Oriskany Boulevard. Customers could enter the store on Roosevelt Drive through the back door, as well as the front. Tobacco was a big sales item, as most people smoked at the time. When big chains like Victory Market and A&P came to the area, they put the smaller stores out of business.

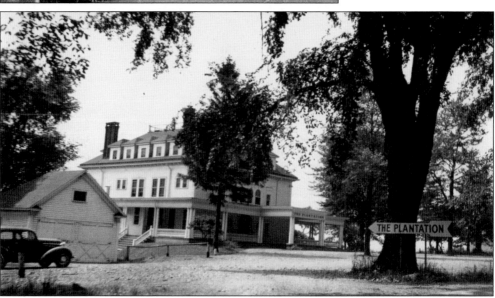

The Hart summer home was sold in the 1940s and became the Plantation Restaurant. It was advertised as a real "shore dinner" serving "plantation-style" meals for $3 per person. Patrons could eat on the beautiful wraparound porch, weather permitting.

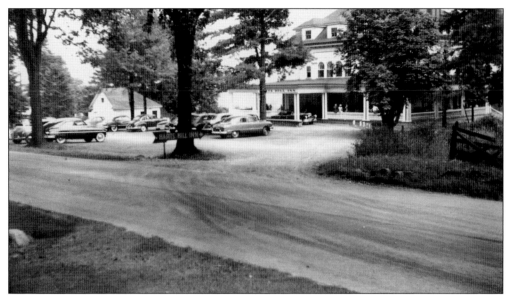

In 1950, Frank and Emma Schnabl bought the Plantation Restaurant and named it Hart's Hill Inn. They advertised it as the only eating place of its kind in central New York. Emma's German cooking was featured.

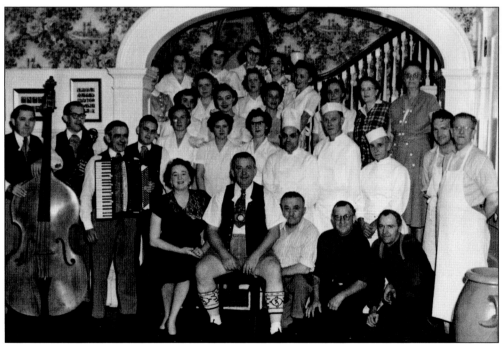

Posing in the lobby of Hart's Hill Inn are Frank and Emma Schnabl (first row, seated center) and everyone who kept the restaurant going, including the band. Very often, the Schnabls would dress in German costume and dance with the band.

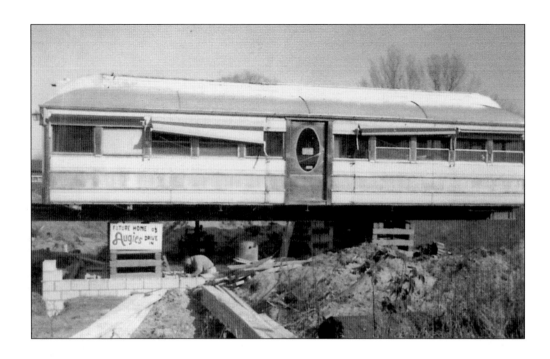

Diners were popular in the middle of the century. In 1963, August "Augie" Aubert opened one in Whitesboro, operating it on Oriskany Boulevard for nearly 30 years. It was originally Smiley's on South Street in Utica. Today, it is Bev's. It has been remodeled and expanded, and it does a very good business. Shown above is the diner being put into place, and the image below shows it being readied for transport.

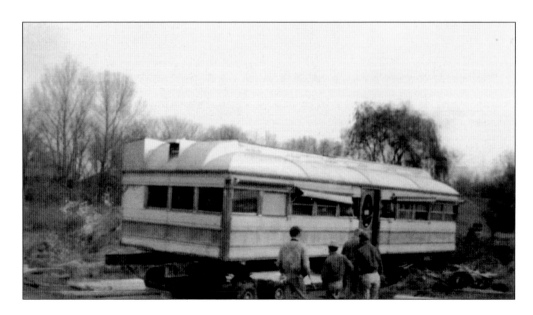

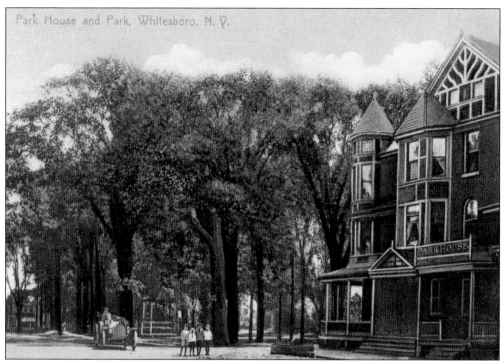

Park House and Park, Whitesboro, N. Y.

This postcard shows the Park House Hotel on the corner of Main and Clinton Streets. In the front is a water trough, and in the back was a barn to keep guests' horses. For $2 a night, guests had a choice of 25 different rooms, the use of a sunlit dining room, and a reading and smoking room. The hotel experienced three fires, and it was rebuilt each time. The Eldredge family was the last to own the hotel. The building is now offices and apartments.

Visible in this postcard are trolley tracks, on the curve just before the Dunham Public Library across from Village Green. The large house in the left background belonged to the Tessey family. Edward Tessey was a well-known photographer who took many school and family portraits. He also took the photographs for D. Gordon Rohman's book *Here's Whitesboro*. The previous owners of this home are unidentified, but it is one of the oldest houses in the village. Tessey's daughter Suzanne has given piano lessons to many children and adults and still lived in the home until 2014.

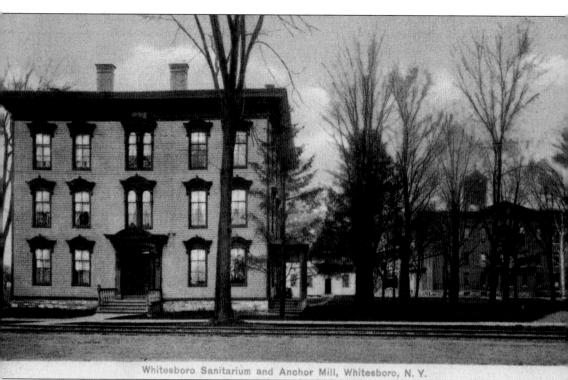

Whitesboro Sanitarium and Anchor Mill, Whitesboro, N. Y.

This postcard features the Whitesboro Sanitarium, which offered what was known as "The Gold Cure." A short time after the Whitestown Seminary closed, Whitesboro acquired a medical facility that, for a while, obtained nationwide fame for its treatment of alcoholism. It opened in 1903 and was operated by Henry Baker, a physician; Alfred Bayliss, superintendent; and Fred Bayliss, president. It was sometimes known as the Gold Cure Sanitarium, taking its name from the method of treatment: a solution of tincture of gold was injected into the patient, who was then given a large quantity of alcohol to drink. The sanitarium continued in operation until it closed in 1919. (Courtesy of the Pugh collection.)

Rosco Lennon stands in front of his store, Lennon's Food Market, on the corner of Westmoreland and Foster Streets. The pony belonged to a photographer who walked around the village, offering photographs for a fee. Children could have their photograph taken while sitting on the horse. For an extra fee, one could wear a cowboy hat, guns, and holster and look like a real cowboy. Many families still possess that cherished photograph.

Lennon's Food Market is seen here in a later photograph. On the left is the dentist office of Dr. Berkowitz. By this time, Rosco Lennon had become mayor of Whitesboro and turned the store over to his daughter to run.

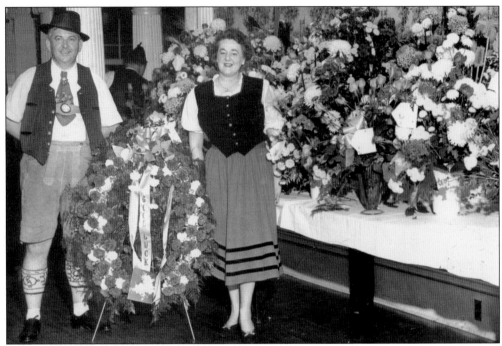

Frank and Emma Schnabl greet their guests in full German costume in 1950 at the grand opening of the new scenic veranda at Hart's Hill Inn. They are posing with flowers, wishing the guests luck all around.

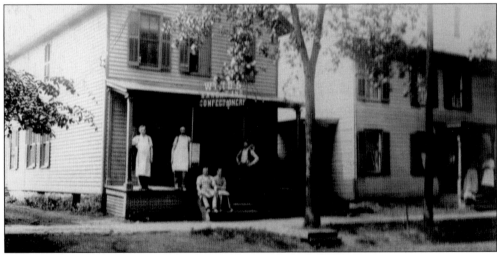

After coming to America in 1891 from the province of Friesland in the Netherlands, Wybo E. Wind settled with his family in New York Mills. He started his employment in textile mills, but his dream was to be a baker. Wind was beckoned to Whitesboro because of its railroad, canal, planned trolley service, and thriving business community. In 1896, Wybo purchased this two-story building on Clinton Street and opened the Wind's Bakery and Confectionery. Many Dutch immigrants came to Whitesboro by word-of-mouth or by invitation to work at the bakery. It operated in that spot from 1896 until 1910, when a new building was erected on Main Street. Pictured are, from left to right, (seated) son Henry and daughter Nellie; (standing) sons Edward, Joseph, and Andrew.

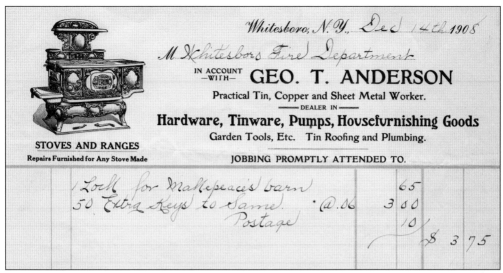

This bill of sale for keys was to the fire department from Anderson's Hardware. The new fire station was built in 1908. The barn may have been used to store equipment while construction took place. The bill accounts for 50 extra keys and a lock for a total of $3.75. Keys were 6¢ each.

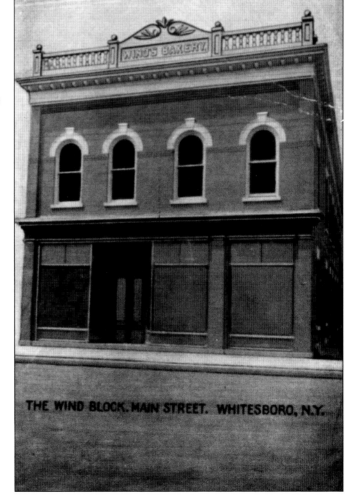

THE WIND BLOCK. MAIN STREET. WHITESBORO, N.Y.

This postcard shows the original Main Street Bakery building that Wybo Wind constructed in 1910. In later years, the ornate top was removed, and a new roof was built. (Courtesy of Linda and Richard Pugh.)

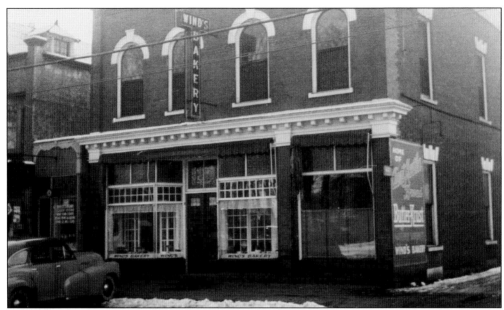

Main Street's Wind's Bakery, "The Home of Holsum Bread," always welcomed visitors to see how their bread was baked. The two-story brick building housed an expanded wholesale baking facility, as well as a retail outlet and garages for the delivery trucks. Other names associated with Wind's bakery products were Aunt Martha's Bread and Butterkrust, shown in the sign painted on the side of the building. The Buck Construction company bought the building after the bakery closed in 1956. The retail store is today the home of Not Just Poodles and a spa.

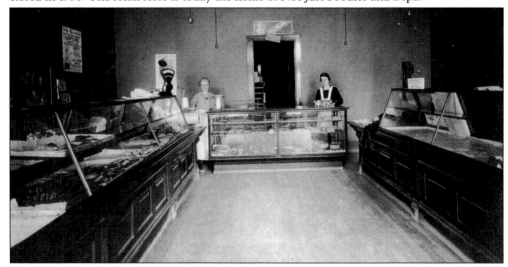

The interior of Wind's retail store had a metal ceiling. Because the door opened into the bakery, the most wonderful smells came through it to lure customers. Shown here are a Mrs. Crandal (left) and Anna Riemersma (right). Anna met and married John Riemersma, one of the Dutch confectioners, who came from the same area in Holland as Wybo Wind with hopes of a job. Riemersma kept a diary of his trip to America and of his first experiences with the bakery. It can be seen at the historical society. An original pie cabinet with "Wind's Baked Goods" etched on the glass can be seen at Hartman's Potting Shed Antique Shop on Oriskany Boulevard in Whitesboro. (Courtesy of Peter Riemersma.)

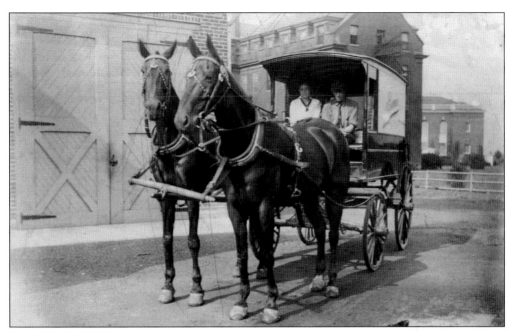

Over the years, the bread made first by Wybo Wind in a kitchen in New York Mills, and later in the bakeries of Whitesboro, had many different forms of delivery. Charlie Davis and his wife, seen here, delivered Holsum Bread in the Wind's Bakery horse-drawn bread wagon. The barn seen here is the back of the new brick bakery building on Main Street. The date of this photograph is July 24, 1915. (Courtesy of Peg Davis Rondeau, their daughter.)

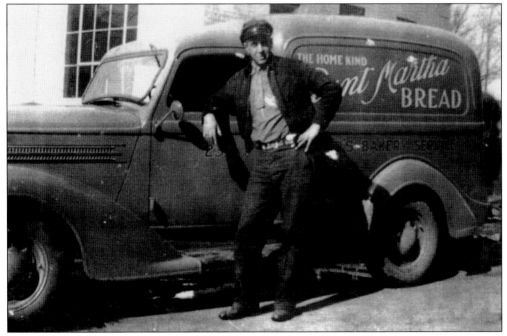

Cornelius "Casey" Harp, 18, was one of the route men for Wind's Bakery. He painted for the bakery when he was 16 years old, and, one day, Wybo Wind needed a driver to retrieve a truck in the city. Wind offered Harp the job. The truck advertises "The Home Kind, Aunt Martha's Bread."

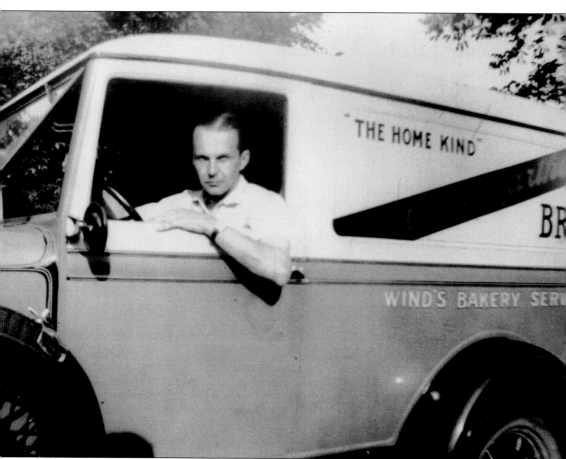

Henry Wind is seen here in 1953, in a newer, brighter-painted panel truck. This model had fancy wire wheels.

Where Our Flour Comes From

THE wide, rolling Western prairies are today covered with wheat. As far as the eye can see stretches the expanse of yellow, waving grain. A hundred years ago those great plains were empty except for the roving tribes and the great herds of buffalo. But today the Indian and the buffalo are gone, and in their place move the big tractors that cut and stack the wheat sheaves.

When the wheat is cut come the threshing machines, that separate the sweet kernels from the straw and chaff. Then these kernels are taken to the mill and ground and sifted and separated from all impurities until we have the fine snowy white flour that makes our bread.

Bread is indeed "the staff of life." It is the most necessary article of our food, and it is naturally important that it should be pure, nourishing and delicious to the taste. Our bread is made with these factors in mind. It looks good, it smells good, it tastes good. And it IS good.

DIRECTIONS—To paint the picture use brush and clean water, rinsing the brush after painting each part. Keep carefully within the black outlines. Paint without paint. Made in U. S. A.

FUN and PRIZES TOO

A different one of these Magic Pictures is enclosed with WIND'S AUNT MARTHA and HOME KIND BREAD every day for 50 days. When you have received 20 different ones, bring them to our Bakery and get the ART FOLIO we are giving FREE. We will tell you how to get cash prizes for painting and arranging the pictures in your ART FOLIO.

WIND'S *Aunt Martha* and ~HOME KIND & BREAD

WIND'S BAKERY Whitesboro, N. Y.

In the collection at the Whitesboro Historical Society are some samples of free gifts that were given to customers of Wind's Bakery, such as the advertisement pictured above. It refers to pictures given away as prizes in the bread.

This item was in a loaf of bread. Customers could collect different cards to try to win a prize. This was likely an early instance of companies placing prizes in products in an effort to get children to ask their mothers to purchase a particular brand.

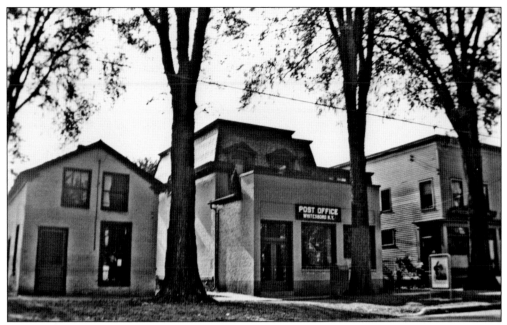

This 1939 photograph shows the Whitesboro Post Office when it was on Main Street near Moseley. In 1792 or 1793, George Washington signed a document designating a post office for Whitestown; the official records show it was established in 1796. The Village of Whitesboro Post Office was established in 1800. Dr. Elizur Moseley was the first postmaster. When he retired in 1825, Mrs. Harry Patton became postmistress. She installed the first house-to-house delivery in the area.

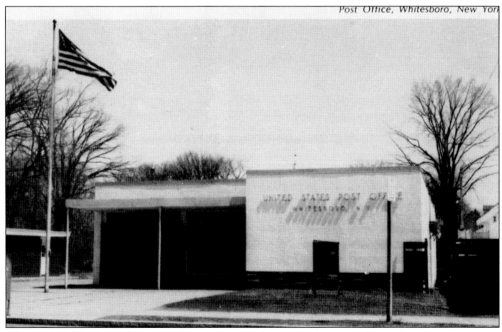

This postcard features the post office on Roosevelt Drive, where it still stands today.

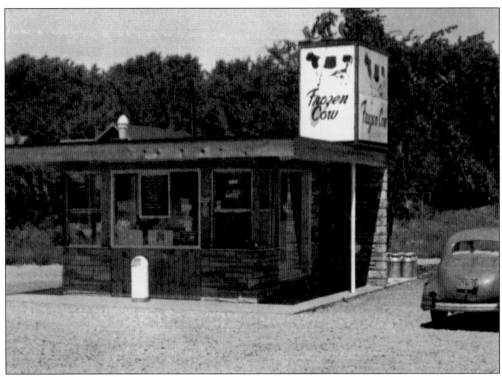

The best place to get strawberry and hot fudge sundaes in the 1950s and 1960s was the Frozen Cow, across from Whitesboro High School. A miniature golf park was added by the establishment's operators, the Zabek family. Business was seasonal, so they started the Boulevard Trailers Business, selling camping trailers, and eventually closed the ice-cream shop. Camping became popular, and the Zabeks expanded their business, still run by the family today.

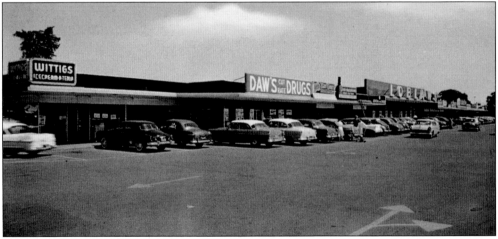

This postcard shows the Whitestown Shopping Plaza, which opened in 1953. It was the first strip mall in the area. It had Wittig's ice-cream parlor, a Ben Franklin five-and-ten store, Foedish ladies' shop, and a Loblaw's grocery store, among others. Wittig's was an after-school hangout, convenient to Whitesboro High School, across Oriskany Boulevard. Students played the latest music on the jukebox and danced. The parlor, resembling the diner in the television series *Happy Days*, had the best hamburgers and cherry Cokes. The plaza is still there today.

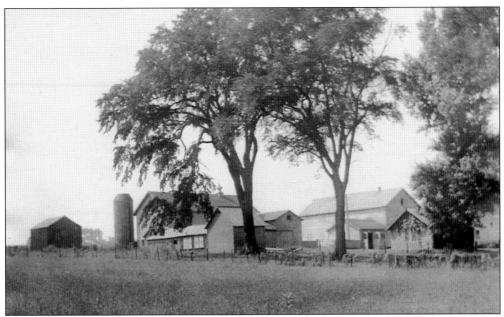

Agriculture was America's business throughout the 19th century, and family farms were very much a Whitesboro staple. This is the William Hughes farm on West Street, an active dairy farm. Gordon Rohman remembers working on the farm. After the chores were done, he and his friends played behind the barn, where there was a hill in the main pasture, known as the Indian Mound. Part of Hughes farm is today Herthum Heights development, which includes a street named Indian Mound Drive.

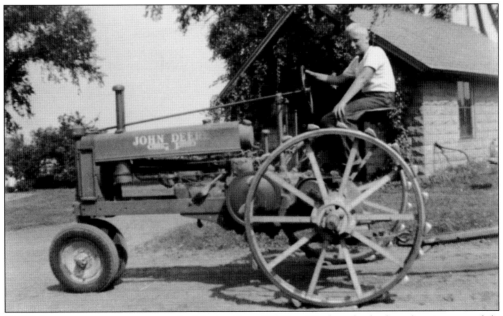

Cal Rohman operates a tractor on the Hughes farm. William Hughes also had an electric automobile that he drove in the main pasture behind the barn. The farm was on a hill. From the high pasture on West Street above the Grand View Cemetery, one could see all over the Mohawk Valley, in a time when trees were still abundant and before the area was built up with houses.

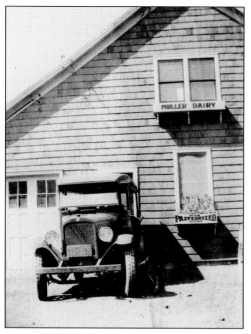

In the 1930s, milk was produced in Whitesboro and delivered to customers' doors. The cream would be on top of the bottle, and, often, the lady of the house skimmed off the cream to use for afternoon tea, coffee, desserts, or cereal, leaving what is known today as two-percent milk. Muller's Dairy, Otter's Dairy, and both Britt Brother Dairies on either side of Oriskany Boulevard were very busy at the time. Later, Muller's processing plant, pictured here, was replaced by a cement-block building on Waterbury Avenue, off Westmoreland Street.

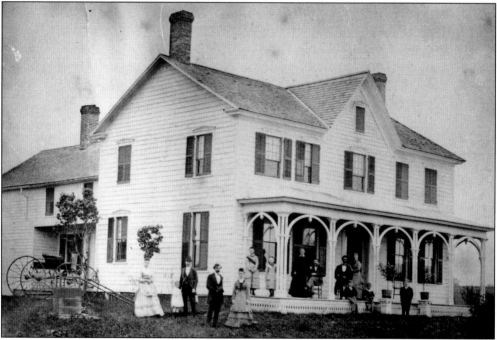

Hart's Hill Farm was located on Clark Mills Road in the town of Whitestown. Kent and Michele Roberts are in the process of restoring the old family homestead. The farm is an organic operation, and the main crop is garlic. The land is part of the Cox Patent, owned in 1774 by Sylvester Parmalee. Kent is the second generation to farm the land. The 840 Highway dissected the farmland, taking up much of the horse pastures and compromising the organic status of the fields due to runoff. Kent Roberts had to refigure the fields to maintain the quality of his garlic, rated one of the highest in New York.

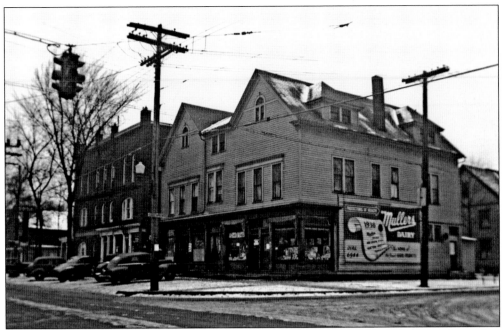

Muller's Dairy, off Westmoreland Street in a cement-block building, was in a residential area that did not allow business signage and with little traffic. Muller's made up for it by putting a billboard on the side of the Victory Block building on the corner of Westmoreland Street. Residents headed down Main Street could not miss the sign. The sign shows the year 1938.

The Dumka Poultry Farm was the place to go for fresh chickens and eggs. Its slogan was "If it's from Dumka's—It Must Be Good." Here, a mother shows her daughter the little baby chicks raised on the farm. Customers could bring a fresh-butchered chicken home for dinner that had not been penned up—what is today called free-range chicken. Part of this farm is the Westmoreland School yard today.

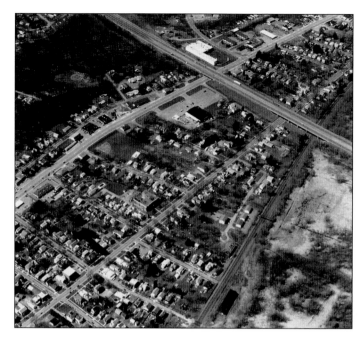

This aerial photograph includes the New York State Thruway (left). Oriskany Boulevard runs from left to right in the upper portion of the photograph. The railroad tracks run from the bottom of the image to the upper right. At the intersection of the thruway and Oriskany Boulevard is the discount Furniture Store. The thruway went through the middle of the Fred Gabel farm and cut off pastureland farther up the hill. The farms were sold because the cows no longer could get to the other side of the road.

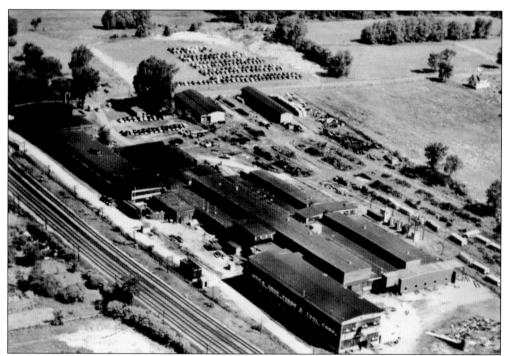

This is the Whitestown plant of the Utica Drop Forge & Tool Company in 1952. It was located across the tracks, off Mohawk Street. It used to be in the village before boundaries were changed. Mohawk River used to be the end of the village. Utica Drop Forge & Tool Company moved up the hill and became Utica Corp. Today, it is Tect Utica.

Three

ERIE CANAL
AND RAILROADS

Gov. DeWitt Clinton had a dream that most people thought amazing but impossible. He proposed construction of a waterway that would make trade and travel easier. That dream became a reality when Clinton built the Erie Canal through the center of the state, dividing farmland, dissecting roads, and, in some places, going over rivers. Whitesboro was part of the first dig when ground was broken at dawn on July 4, 1817. Rome, New York, was chosen because it was the level center of the land, so Oriskany, Whitesboro, and Utica were the first to see a section of the canal completed. Running from Buffalo to the Hudson River, the canal, 363 miles long, took until 1825 to complete. The final cost was $7,143,789, and by 1883, it had earned 17 times that amount ($121,651,871) in total revenue.

Whitesboro takes pride in the canal because the grandson of its founder, Hugh White, devised the waterproof cement that made the construction of the canal successful. Canvass White, a civil engineer, invented a hydraulic cement that hardened under water. He was also the canal's lock designer. The Erie Canal was replaced by the larger Barge Canal in 1918. Some years later, the canal was filled and called the "Truck Route." Today, it is known as Oriskany Boulevard. Only freight was hauled on the barges, so passenger travel was mostly done by train. Trains were faster and ran all winter when the canal closed. Tracks were built throughout the state, dissecting farms along the way. Tunnels were built to get the cows to the pastureland on the other side of the tracks. Train whistles can still be heard, but now there are only two tracks instead of four.

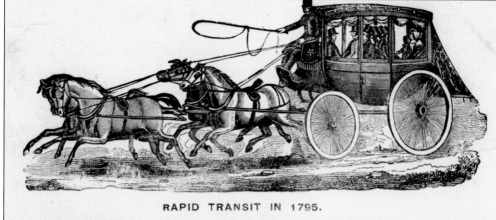

RAPID TRANSIT IN 1795.

THE STAGE COACH.—The pioneers in the Stage Coach enterprize were: Jason Parker, T. S. Faxton, John Butterfield and Silas D. Childs, all Utica men. Fare, Utica to Alban , $5.00 to $6.00 Time, 24 to 48 hours depending on condition of roads.

After taking over the mail-carrying contract from Simon Pool, the original carrier, Jason Parker began dreaming of a stagecoach line. Prior to this, he was a post rider on foot, or by horse when possible. When roads improved to permit stagecoach travel, he started his first stagecoach line, the Great Western Mail. The first trip was made from Canajoharie to Fort Schuyler, then to Whitestown in 1795. This postcard advertises "Rapid Transit in 1795". Passengers could travel with the mail, paying a fare; from Utica to Albany was $5 to $6. The trip took 24 to 48 hours, depending on road conditions.

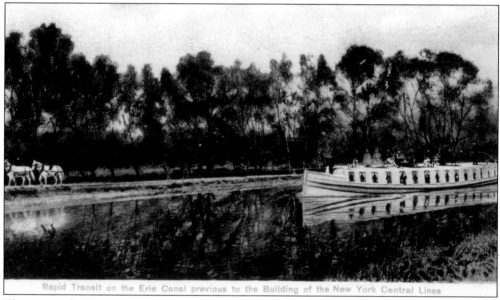

Rapid Transit on the Erie Canal previous to the Building of the New York Central Lines

This postcard offers an example of the large packet boats used for travel on the Erie Canal. It took a team of horses to tow. People are seen on the roof of the boat, enjoying the ride and sights. In a song about the Erie Canal, a line says, "low bridge everybody down." People sitting on top of boats had to duck, or else ladies would lose their hats and gentlemen who were standing could be knocked into the canal. Some of the walking bridges over the Erie Canal had to be low enough for farmers to take cows across to pastureland that the canal ran through and for residents to cross to get to stores on the other side.

These two boys, dressed in their Sunday best, watch for a canal boat to pass by at Foster Street around 1920. These friends spent many hours playing and fishing. The canal's fish likely came from Lake Delta, the Mohawk River, and Oriskany Creek, whose water kept the levels of the canal up. Neighborhood boys would jump into the canal to retrieve hats for ladies who did not hear the call of "low bridge." They were sometimes rewarded a nickel.

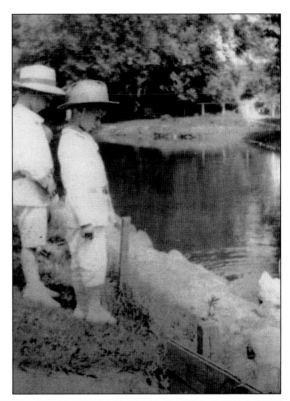

This is the back of Stephenson's Store, facing Foster Street. The front of the store faced the canal. Boats could fill their 2,000-gallon tanks with the best springwater for free. "Canallers" had a choice of two stores for supplies: Stephenson's and Symonds, which was down the canal at Westmoreland Street. Milk could be purchased for 2.5¢ a quart, eggs for 1¢ each, and three pounds of cheese for 25¢. Rubber overcoats were $2.50, shoes cost $1.25, and salt port, a canal favorite, was 10¢.

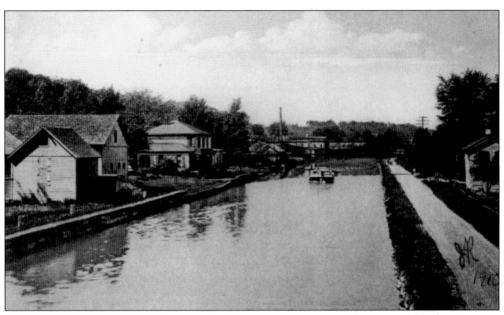

This postcard is showing the Erie Canal looking west. The tow path is visible on the right. The Quigley Furniture Company can be seen in the far background.

Pictured here is a receipt from Stephenson's store in 1891. The store was on the Erie Canal, and, as one can tell from the receipt, many different items could be purchased from there.

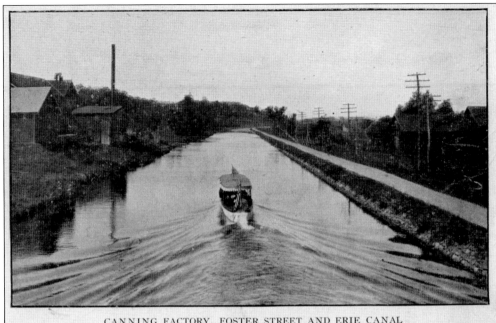

CANNING FACTORY, FOSTER STREET AND ERIE CANAL

In this postcard of the Erie Canal, the canning factory is on the left, and the cheese factory is at right. In Charles Sperry's book *Whitesboro, My Home Town* (1982), he writes that Sir Thomas Lipton, the noted tea merchant and yachtsman of London, purchased some cheese on a trip through Whitesboro. Lipton was so impressed by the cheese's quality that he ordered a 2,000-pound cheese for promotion of his tea sales in England. He gave the cheese away for free. Lipton said, "There is only one place to get this cheese, America, and only one man whom I knew could make it, Dr. L.L. Wight of Whitesboro.

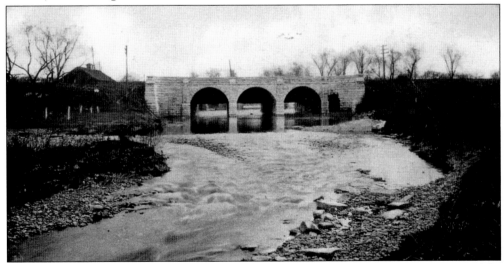

The aqueduct over Sauquoit Creek was necessary for the passage of Erie Canal boats. Parts of the stone bridge can still be seen near Whitesboro Middle School. A better example of an aqueduct can be seen over the bridge on Oriskany Creek on Route 69. That aqueduct runs parallel to the highway. When boats came to the aqueduct, water was pumped from the creek to the bed to float the boat across.

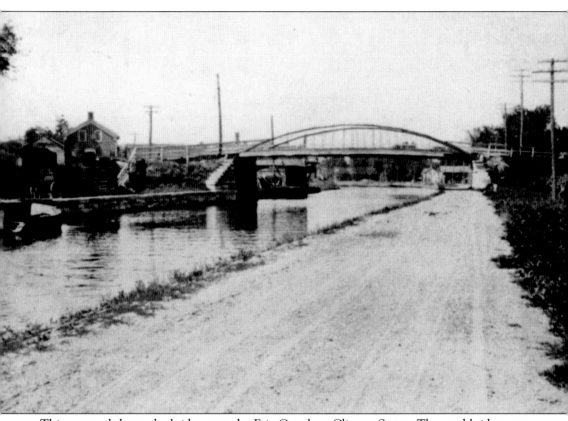

This postcard shows the bridge over the Erie Canal on Clinton Street. The road bridges were built higher than the foot bridges to give canal boats more room to pass. Motorcars could make the grade, unlike cows and people, who used the walking bridges.

TRAGEDY AT BRADLEY' BRIDGE !!

The Saturday Globe.

Published every Saturday at 20, 22, 24 and 26
Whitesboro street, Utica, N. Y.
WILLIAM T. AND THOMAS F. BAKER,
PROPRIETORS.

SATURDAY, AUGUST 13, 1898.

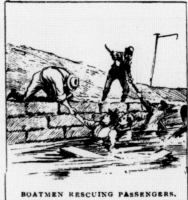

BOATMEN RESCUING PASSENGERS.

BRADLEY'S BRIDGE WRECK.

THE ACCIDENT AT ORISKANY SUN DAY AFTERNOON.

It Might Have Been One of the Most Shocking Disasters Ever Recorded—The Dead, the Rescued and Rescuers—Scenes at the Wreck.

BUT for a few fortunate circumstances the accident on the Belt Line Railroad, · between Whitesboro and Oriskany, Sunday, would have been one of the most shocking ever recorded in this State. As it was the escape from death of all but one of 30 passengers, who went down into the canal and its embankment with the broken Bradley's bridge, must be regarded as miraculous.

That more were not killed is due to the presence of mind of some of the passengers and the heroic work of canal men and farmers living in the vicinity of the accident.

Sunday afternoon more than a thousand persons went up to Summit Park. Up to 4 o'clock every west-bound trolley train carried from 100 to 150 passengers. Had the bridge gone down with one of these loads on it, how horrible must have been the result! A score of lost lives and dozens of broken limbs might have been the harrowing consequences. Even more terrible would it have been had the bridge remained intact until at night and then broken under the load of a trolley train crawling over it. In the inky darkness it would have been possible to save but a few of those who went into the water and there would be mourning for lost ones in scores of homes in central New York.

It was about 4:45 Sunday afternoon when the trolley train, with Herbert Hughes as motorman, William Gilloran conductor of the motor car and Gus Goehring conductor of the trailer, approached Bradley's bridge from the west. On the two cars were 30 passengers, 18 on the motor car and 12 on the trailer. Among them were Miss Mary Brady, Miss Anrie Kavanaugh, Miss M. Bray, Mrs. Elizabeth Smith and two daughters, George J. Young, Miss Clara Remington, Herbert A. Cheeseboro and Master Clarence Cheeseboro, James Long, Miss Slodowski, Henry Smith and E. D. Weil, of Utica; Mr. and Mrs. John C. Bray, of Ilion; Mrs. Walter Davis, Hugh Davis and Mr. Murphy, of Whitesboro.

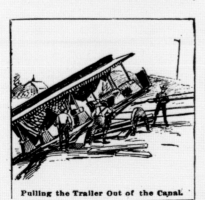

Pulling the Trailer Out of the Canal.

The *Saturday Globe* reported the "Tragedy at Bradley's Bridge" on August 13, 1898, on the Erie Canal just west of Whitesboro. On a Sunday afternoon, a trolley car went into the canal as the Bradley Bridge collapsed.

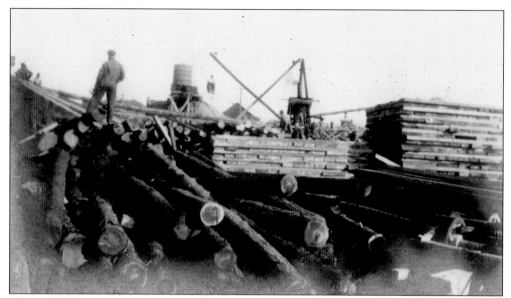

The Barge Canal, built to replace the old Erie Canal, accommodated larger boats, making it much more economical for hauling freight. The motor replaced mules and horses, and the Erie Canal closed. This 1913 photograph shows the equipment and material used in building the canal. Cranes did the lifting, and machines did the digging. Just as immigrants from Ireland worked on the Erie Canal, many workers on the Barge Canal were Italian and did not speak much English. Anthony Curtacci was hired as the foreman because he could speak English and Italian.

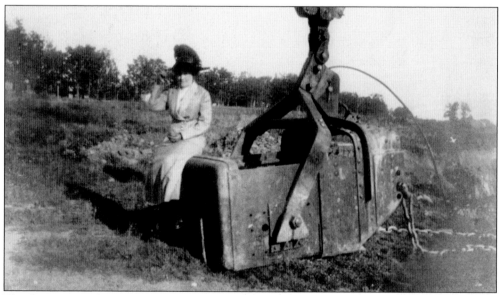

This large piece of equipment was brought in to dredge out the Barge Canal. Machines made it easier on the men, but it was still hard labor. The woman seen here on September 14, 1913, wears fashions of the day, which included large, fancy hats and gloves.

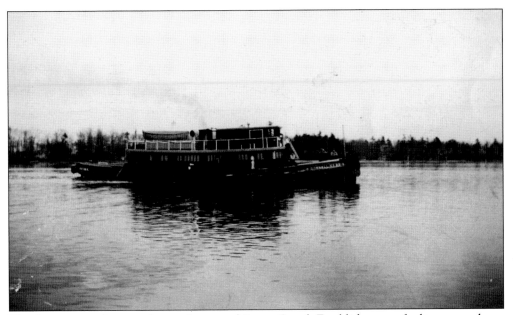

This boat is traveling on the newly opened Barge Canal. Establishment of a larger canal was necessary to accommodate the increased amount of freight. Whitesboro was bypassed; the new canal ran parallel to the Mohawk River on the other side of the New York Central Railroad.

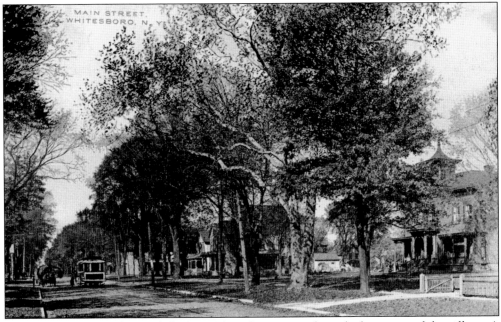

In this postcard, the dirt road that was Main Street runs through the center of the village. A trolley car (left) runs on the tracks that appear to be in the middle of the road.

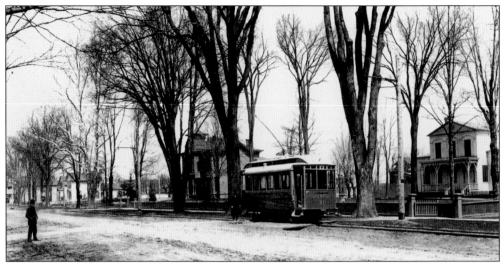

In Robert G. Gurley's *Here Comes the Trolley*, he states that enough records of the 1870s show that the City of Utica possessed a number of well-developed horse-car lines extending to the neighboring suburbs of New Hartford and Whitesboro. The introduction of the electric trolley in the middle of the 19th century was the beginning of mass transportation. Pictured here in 1890 is the first trolley in Whitesboro. (Courtesy of Oneida County Historical Society.)

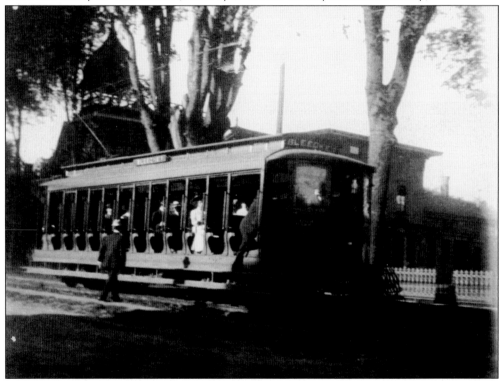

Some early trolleys were horse-drawn with open cars that had straw to help cushion the rough ride and keep feet warm in the winter. The car is in front of the Methodist church on Main Street. The passengers appear to be dressed up and are likely going to Utica. Dirt roads must have made for dusty trips.

This is a map of early Whitesboro, date unknown. The map shows the Erie Canal, the Mohawk River, and the Utica & Whitestown Horse Railroad (horse-drawn trolley).

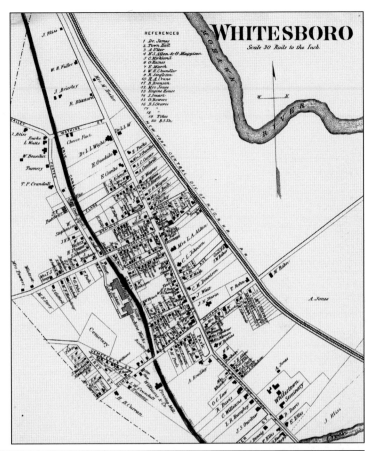

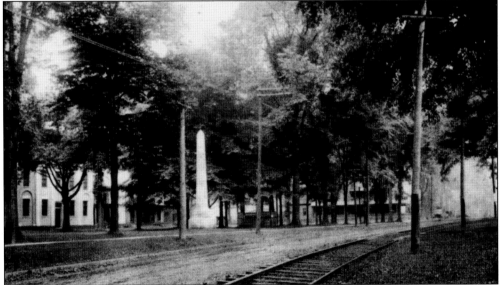

This very old postcard shows Main Street and Village Green. The Whitesboro Town Hall, White's Monument (the obelisk), and the Park House Hotel are seen in the background. The old wooden bandstand next to the obelisk can be seen with a magnifying glass.

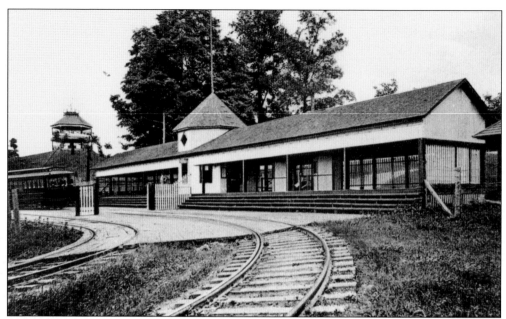

This is the trolley car entrance to Summit Park in Oriskany, which opened in 1896. Trolleys came from Utica through Whitesboro and took commuters to this pavilion, which contained a turnstile. This was the only entrance in 1903.

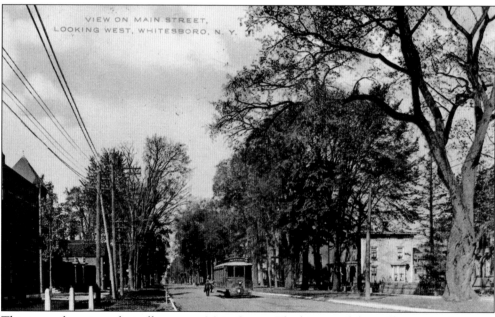

This is another view of a trolley car on Main Street. The history of the trolley car in the upper Mohawk region begins in the early 1860s, when a network of horse-cars knit Utica and its suburbs together. In 1890, the trolley line was converted to electricity. The trolley made its last run in Whitesboro on July 6, 1938, before being replaced by new buses after a "satisfactory agreement" between Whitesboro mayor Roscoe Lennon and the Utica Lines of the New York State Railways. A later agreement was made so that half the buses would run over the truck route (Oriskany Boulevard).

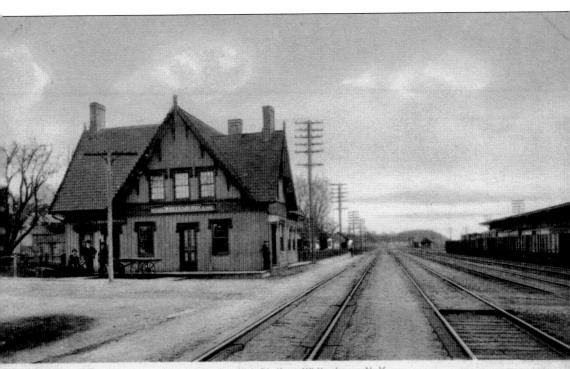

New York Central Station, Whitesboro, N. Y.

The New York Central Railroad station, seen in this postcard, no longer exists. The freight station is still across the tracks from the end of Linwood Place. When in use, the station was a stop for belching steam engines pulling trains to pick up and drop off mail and passengers and to arrange freight shipments. The original station, moved to the location shown here in 1919, was a combination ticket office, waiting room, and express office. It also contained living quarters for the first stationmaster, Silas Purdy, and his family.

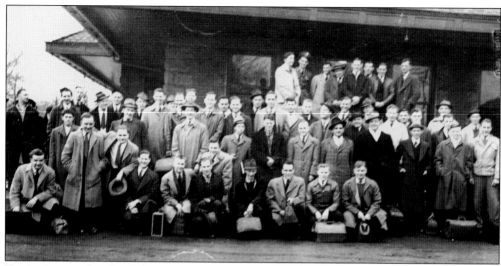

Train stations played an important part in World War II, serving as a place where loved ones saw men off to war and welcomed them home. This photograph, dated November 7, 1941, is described by the *Rome Daily Sentinel* as follows: "Sherrill Draft Board 343 today sent men to Fort Niagara, the first group to have been passed by physical tests before being sent to induction centers." Among those pictured above are Fred Zoladz of New York Mills, Benjamin Curtacci of Whitesboro, Anthony E. Nogas of Yorkville, Joseph J. Kurgan of New York Mills, and Edward Clawson of Oriskany.

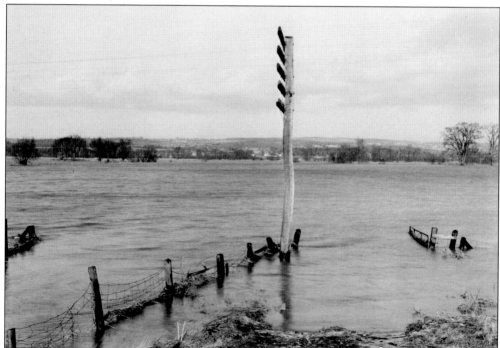

This is an official photograph taken for village records on February 7, 1938, between 3:00 and 3:30 p.m. on the H.B. Kenyon property. This is the location of the right-of-way over the train tracks on the Kenyon farm, across from Whitesboro High School, when it was on Main Street. The flats flooded every spring when the snow melted, and the Mohawk River overran its banks.

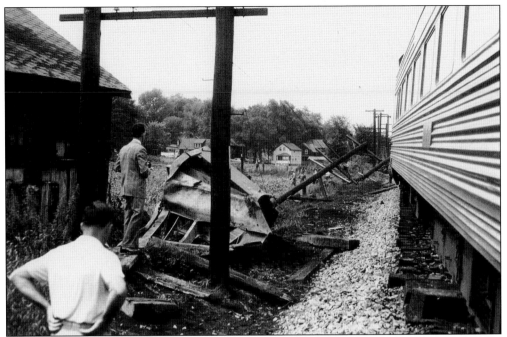

On August 14, 1953, this train wreck happened in Whitesboro during construction of the New York State Thruway. A truck carrying a sheep foot roller (a piece of construction equipment) and became stuck on the railroad tracks. The engineer tried to stop, but was unable to, hitting the roller and derailing the train.

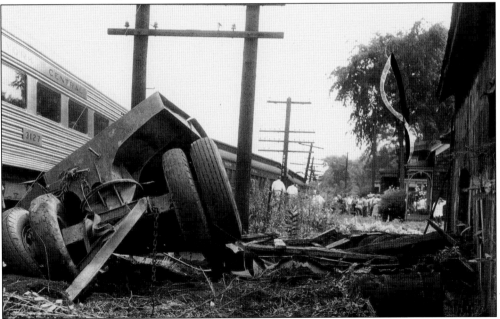

This photograph shows the damage done to the property on Pleasant Street after the sheep foot roller was struck and pushed off the tracks and into the barn owned by Laura Jones, just missing her home. The barn was badly damaged. Photographs were taken for insurance purposes and donated to the Whitesboro Historical Society.

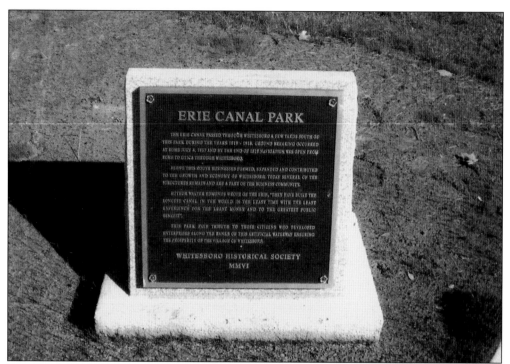

Erie Canal Park is dedicated to those who developed the businesses along the canal that helped ensure the growth and prosperity of the village of Whitesboro.

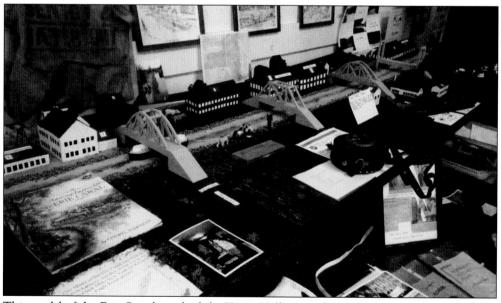

This model of the Erie Canal was built by Kevin Kallassy and Boy Scout Troop 44 from Clark Mills, New York, for Kevin's Eagle Scout project. The model is part of the Whitesboro Historical Society's exhibit.

Four

CHURCHES
AND CEMETERIES

From the time Hugh White held the first church service in his barn, his faith and love of family left a great legacy for the future generations that made the village of Whitesboro and the town of Whitestown their home. The donation of land for the Grandview Cemetery, the town hall, and the beautiful Village Green are of that legacy.

The Village of Whitesboro created a commemorative book for the sesquicentennial. The chapter "Historical Reminisces 1813–1963" includes this passage: "A History of this kind must be largely fragmentary and traditional, and yet authentic as possible." Much of this material was taken from a *History of Whitesboro*, written by a Miriam Whitcher, a former villager, and also some from the pen of William G. Stone, a former local historian, in tribute to M.L. Whitcher, who wrote "Few Stray Leaves." This chapter in the history of Whitesboro is not only given as a conclusion of her book, but as an addition of the graveyard and churches she said she left out because she had met the proposed limit to her writing. She stated that the subject is left in the hope that someone will write a fuller and more complete history for which a century's existence furnishes ample material. It is the hope that this tells more of the story of the importance of a church for religion and fellowship, a resting place when earthly life is over, and gives some insight of the devotion of the inhabitants of the village.

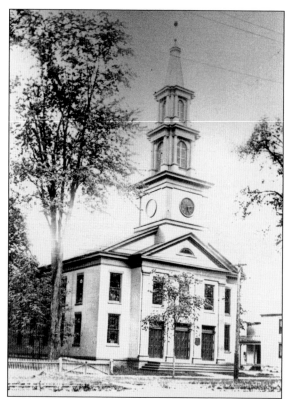

In 1786, two years after Hugh White and his family settled in Whitesboro, a religious society was formed, known as the United Society of Whitestown. The First Presbyterian Church of Whitesboro is an outgrowth of that society. The first pastor was Rev. Bethuel Dodd. A frame structure was erected in 1803. It was torn down in 1934 and replaced with a brick building that still stands. In July 1979, the church was ravaged by fire, but it was later reconstructed. The steeple was added in 1989.

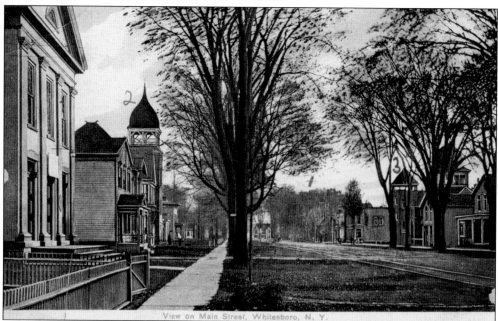

This postcard of Main Street shows the Presbyterian church (left), the Methodist church (second from left), and, across the street, the Baptist church. Across from the Presbyterian church is St. John's Episcopal Church (not pictured). At the time, all denominations were found within a two-block area of the village, including St. Paul's Catholic Church, also not pictured.

The men's Bible study group poses on the steps of Whitesboro Presbyterian Church.

At left in this postcard is the home of abolitionist and former minister of the Whitesboro Presbyterian Church, Beriah Green. He was also once president of the Oneida Institute and a friend of Gerrit Smith of Peterboro fame. In 1839, Green established a printing office upstairs in the pail factory of Oneida Institute, where, in 1842, he published the paper owned by the Anti-Slavery Society called "Friend of Man." Green was let go by the church when it became divided over slavery and felt he was too controversial. Green's final sermon stated, "He that doeth righteousness is righteous." Just four minutes into a later speech, he died on the town hall steps from a heart attack at age 79.

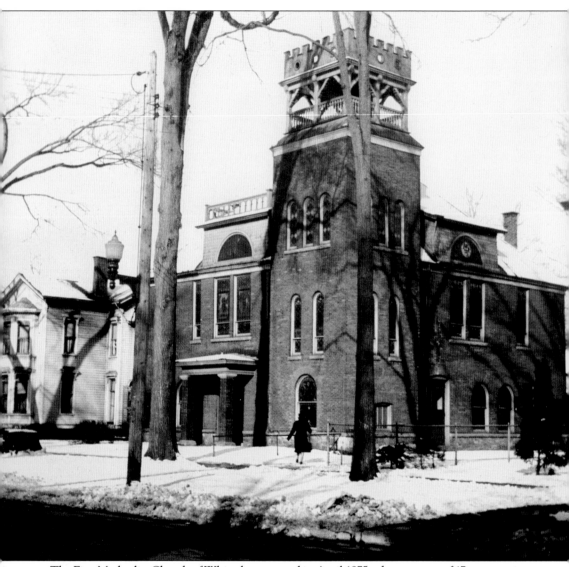

The First Methodist Church of Whitesboro started in April 1875, when a group of 17 communicants met at the home of Hiriam Crain. The church building pictured here was erected and dedicated in 1891. In 1959, the church purchased the Ablett property next door for a parsonage. The Ablett house was sold, and the Methodist congregation merged with the Utica Methodists, becoming Trinity Methodist, on Westmoreland Road, across from Whitesboro Westmoreland Road School. The church on Main Street is today Bethel Baptist Church.

The wooden Baptist church was destroyed by fire on December 7, 1898. It stood on the corner of Tracy Street.

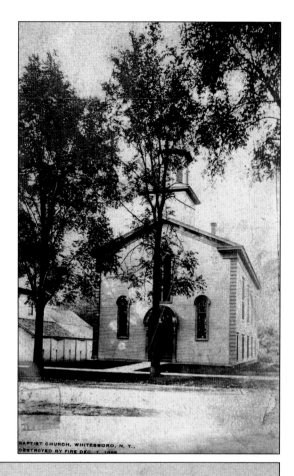

BAPTIST CHURCH, WHITESBORO, N. Y., DESTROYED BY FIRE DEC. 7, 1898.

This is an invitation to the "Corn Festival," hosted by The Young Ladies of the Baptist Society in Whitesboro. It took place in the "Church Parlors" on Monday evening, April 9, 1883. Admission, including supper, was 15¢.

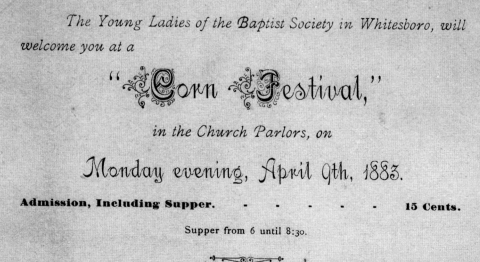

The Young Ladies of the Baptist Society in Whitesboro, will welcome you at a

"Corn Festival,"

in the Church Parlors, on

Monday evening, April 9th, 1883.

Admission, Including Supper. - - - - - 15 Cents.

Supper from 6 until 8:30.

"He that withholdeth corn, the people shall curse him; but blessings shall be upon the head of him that selleth it." Prov. xi. 26.

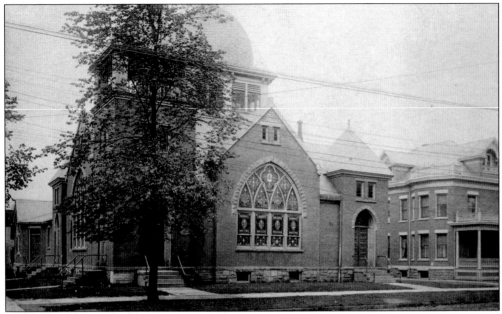

Whitesboro Baptist Church was founded by Elder Parsons, who settled in Whitesboro in June 1796. The first frame building was destroyed by fire. In July 1899, the cornerstone of the church was laid, and the building was dedicated in April 1900. On January 25, 1987, the last service was held in this church before it was torn down. Inspectors had found a crack in the main support beam that held the dome and bell tower.

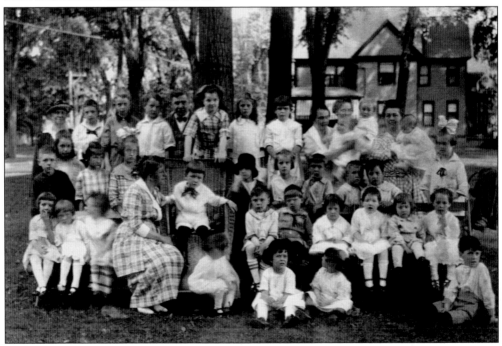

Pictured here are the children of Whitesboro Baptist Church. It appears that the Sunday school teacher in the first row is telling the children to stay still for the photograph, likely taken in the 1930s.

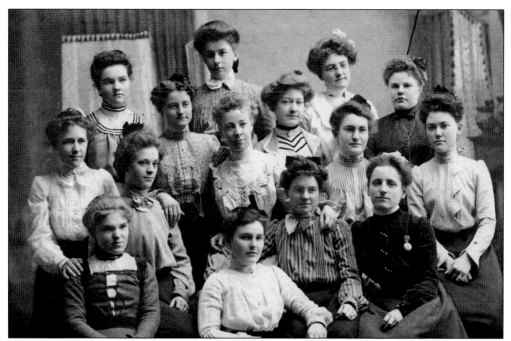

The women's group of Whitesboro Baptist Church is seen here in the early 1900s. The only one identified is Emma Richards Thomas (Mrs. Ray Thomas), in the upper right corner. Ray Thomas had a farm on upper Main Street next to the railroad tracks. Women's groups were an important part of the church, supporting potluck suppers, Sunday school teachers, and social activities at a time when church was very much a part of everyday life.

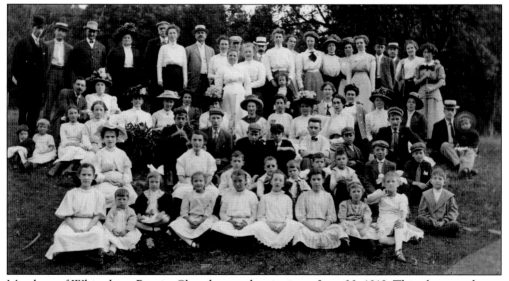

Members of Whitesboro Baptist Church attend a picnic on June 30, 1919. This photograph was taken by Charles H. Hebard. His photographs are distinguished by the label on the back of each one. The label for this image reads, "A group of folks having a picnic, taken by Charles H. Hebard of Whitesboro, New York, about five o'clock in the afternoon." He always recorded the time of the photograph. On some of the pictures in the Whitesboro Historical Society collection, he describes where he stood to take the shot.

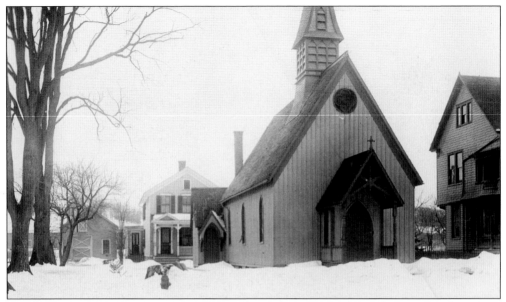

St. John's Episcopal Church was organized in December 1844. In the early days, church services were held in several buildings, including the Whitestown Academy and the courthouse (town hall). In June 1855, the cornerstone of the first St. John's church was laid and a wood frame building was erected. Later, this was torn down, and the present cement-block building was constructed with the traditional Red Door, a symbol of the Episcopal Church. On Christmas 1953, the congregation worshiped in the new church. On Easter Monday 1954, Bishop Peabody dedicated the building and its appointments.

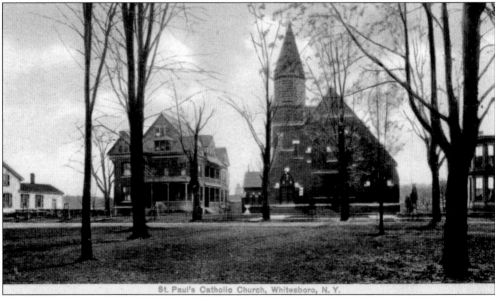

St. Paul's Catholic Church, Whitesboro, N. Y.

St. Paul's Parish was founded in 1882. The church was dedicated in October 1886. The building pictured above became too small and was torn down. A new church building was erected and dedicated in 1972, when Rev. Vincent J. Donovan was pastor. The new church is in the spot where founder Hugh White built his log home in 1784. The rectory is still in use, and the new church is still on the site.

This is the present St. Paul's church, built on the corner lot where the Doughty House once stood. Before Victory Parkway was the location of houses, the land sloped down to what was formerly the bank of Sauquoit Creek, where Hugh White built his first log lean-to before he constructed the log home up the bank. The lighted steeple is a welcome sight at the end of the Village Green.

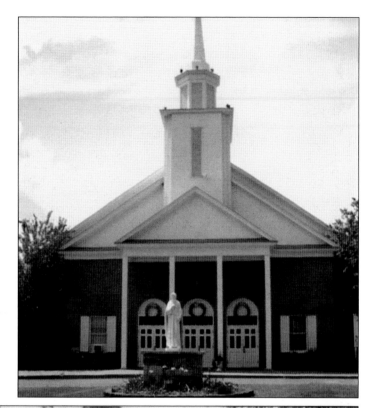

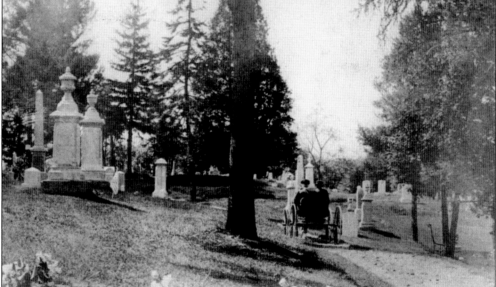

This Grandview Cemetery postcard shows a couple in a horse and buggy at the lower entrance, off West Street. After church and Sunday dinner, many families would walk or ride through the cemetery. People visited family graves, laying flowers, saying prayers, and relating the history of the deceased to the younger generations. The top of the hill on a clear day offers a panoramic view of the Mohawk Valley. To the left of the gate on West Street is the chapel, which has a beautiful stained-glass window in front and an old-fashioned pump organ.

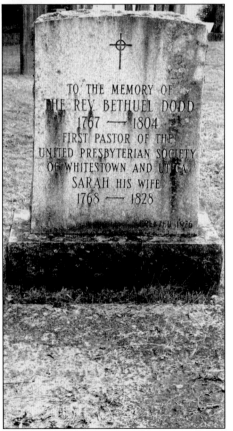

TO THE MEMORY OF
THE REV BETHUEL DODD
1767 — 1804
FIRST PASTOR OF THE
UNITED PRESBYTERIAN SOCIETY
OF WHITESTOWN AND UTICA
SARAH HIS WIFE
1768 — 1828

Here sleeps the mortal remains of Hugh White. His grave is marked by an unusual tablet-style monument in Grandview Cemetery. The inscription reads as follows: "Hugh White who was born 5 February, 1733, at Middletown, in Connecticut, and died April 16, 1812. In the year 1784 he removed to Sedauquate, now Whitesborough, where he was the first white inhabitant in the state of New York, west of the German settlements on the Mohawk. He was distinguished for energy, and decision of character, and may be justly regarded as a patriarch, who led the children of New England into the wilderness. As a magistrate, a citizen and a man, his character for truth and integrity was proverbial. This humble monument of veneration for his memory is reared and inscribed by the affectionate partner of his joys and his sorrows, May 15, 1826."

As part of the American bicentennial celebration in 1976, Whitesboro Presbyterian Church erected this monument to Rev. Bethuel Dodd (1767–1804), first pastor of the United Presbyterian Society of Whitestown and Utica. The original stone is unreadable and lies on the ground below the new one. Dodd preached every Sunday in Whitesboro and in Fort Schuyler, Utica, using the same sermon.

There are a few individual enclosures surrounded by wrought-iron fences in Grandview Cemetery. These enclosures have several graves within them. Thomas R. Gold's imposing red stone monument is in one such enclosure, at the top of the hill. He was born in Cornwall, Connecticut, on November 4, 1764, and died on October 25, 1827. Gold graduated from Yale College in 1786 and came to Whitesboro when he was 28 years old. He set up a law practice with Theodore Sill, the law firm Gold & Sill. In 1796, he was elected New York state senator, serving until 1802. He also served as assistant attorney general for the State of New York from 1796 to 1801. He was a lawyer, congressman, and important founder of the First Religious Society, the Presbyterian Church.

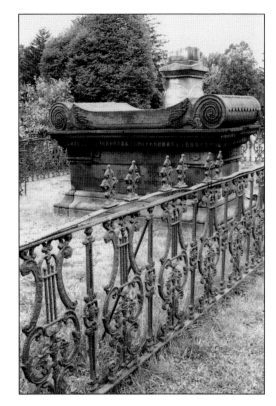

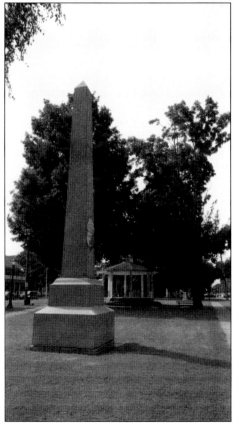

In June 1884, a monument was erected on the Village Green near the house of Hugh White. It is 27 feet in height, in the shape of an obelisk. On the front is the following inscription: "To Commemorate the First Settlement of Whitestown by Hugh White and Family, June 1784." In 1978, during a storm, a tree branch fell on the monument and knocked the top off. Repairs were made to the obelisk by D.H. Burdick & Sons in Clinton. A close look reveals the crack.

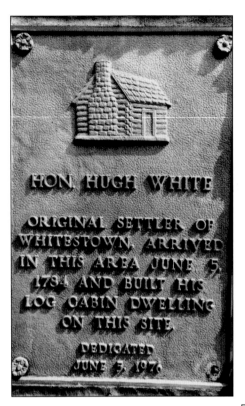

This monument in the Village Green is on the spot where Hugh White first settled in the area. It was dedicated on June 5, 1976, during the American bicentennial.

HON. HUGH WHITE

ORIGINAL SETTLER OF WHITESTOWN, ARRIVED IN THIS AREA JUNE 5, 1784 AND BUILT HIS LOG CABIN DWELLING ON THIS SITE.

DEDICATED JUNE 5, 1976

The label on the back of this Charles H. Hebard photograph reads as follows: "The Lafayette Elm, at the eastern end of the Village Green, in Whitesboro, New York. This tree stands in the yard of the late Mrs. Maude Eagan. It is over seventeen feet in circumference at the base. I took this picture from the steps of St. Paul's Church about 3:30 p.m., March 8th, 1972." The plaque was installed by the Daughters of the American Revolution. After Dutch Elm disease killed the tree and it had to be cut down, the plaque was put on the back of the Hugh White log cabin monument. The plaque reads, "When General the Marquis De La Fayette visited Whitesboro June 10, 1825, he drank from a bubbling spring at the foot of this elm." On Oneida County History Day, October 2009, the Whitesboro Historical Society planted a new, disease-free variety of the elm in the spot of the original one.

1825 1925

WHEN GENERAL THE MARQUIS DE LA FAYETTE VISITED WHITESBORO JUNE 10, 1825 HE DRANK FROM A BUBBLING SPRING AT THE FOOT OF THIS ELM

MARKER PLACED BY THE ORISKANY CHAPTER DAUGHTERS OF THE AMERICAN REVOLUTION

On the Whitesboro Town Hall is a plaque of Canvass White, the grandson of Hugh White. Canvass was a notable member of the group of pioneer American engineers who received their training on the Erie Canal. He first became associated with the canal in 1816, assisting Benjamin Wright in the early surveys. Late in 1817, with DeWitt Clinton's approval, White went to Great Britain to examine canal constructions and bring back surveying instruments. He took out a patent for his waterproof cement on February 1, 1820, after discovering ingredients for a hydraulic cement made from rock in Madison County. His discovery spared the cost of importing cement from England. The plaque reads in part, "The State of New York owes much to his energy and ability in the construction of the Erie Canal." Engraved at the top of the plaque is the depiction of a boat on the Erie Canal.

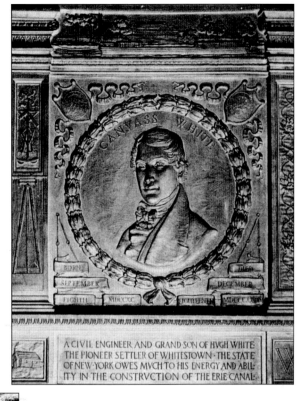

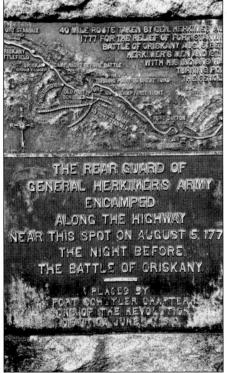

In 1777, Gen. Nicholas Herkimer marched along a route to relieve the forces at Fort Stanwix, resulting in the Battle of Oriskany. The Daughters of the American Revolution commissioned 14 monuments, placed on the 40-mile route from his home in Herkimer to Fort Stanwix. It is said that the Battle of Oriskany was the turning point of the American Revolution. Monument No. 12, in front of the Dunham Public Library on Main Street, reads, "The rear guard of General Herkimer's Army encamped along the highway near this spot on August 5, 1777, the night before the Battle of Oriskany." Main Street was called Military Road at the time. Each monument has a map of General Herkimer's march.

105

Among the Civil War veterans buried in Grandview Cemetery is Joseph Keene, who was in the Battle of Fredericksburg in Virginia. A private, he was a member of Company B, 26th New York Infantry. He voluntarily seized the colors after several color bearers had been shot down and led the regiment in the charge. Joseph Keene was recognized on National Medal of Honor Day.

The Mount Olivet Catholic Cemetery is located on Wood Road on the west side of Whitesboro, partly in the village of Whitesboro and partly in Whitestown. It was organized on April 6, 1892, when its founder, Rev. Father Thomas W. Reilly, purchased 10 acres of the former Fred Gabel farm on behalf of the Catholic Church. Then, 30 years later, 45 acres of land from the same farm were added to accommodate the large growth of the cemetery, which was no longer restricted to just Whitesboro and Whitestown residents.

Fr. Thomas Reilly was accidentally shot while alighting from his carriage on July 7, 1896, at 4:00 a.m., when the revolver in his coat pocket was caught on a handle and the gun discharged. Father Reilly was pastor of the Roman Catholic churches at New Hartford, Holland Patent, and Hinckley, as well as at Whitesboro. Often traveling by buggy at night, Reilly carried a revolver after a previous trip from Hinckley when he was, according to an article in the press, "set upon by two men near Trenton Falls." After his accident, doctors were unable to save Father Reilly, even after Dr. William James operated and removed the bullet. Father Reilly's monument, erected in 1905, is the first one inside the main gate of Mount Olivet Cemetery.

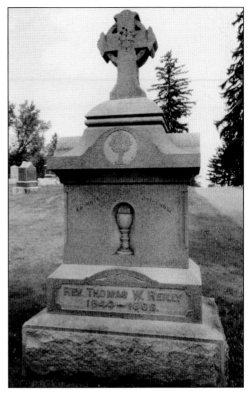

This is the home on upper Main Street where James W. Dimbleby started the Dimbleby Funeral Home business. After completing his training in 1932, he began doing funeral calls out of his father's house. At that time, people held wakes in their homes. A family member would sit with the deceased until the burial. Dimbleby opened a funeral parlor in a large double rented house on Main Street just before Victory Parkway. When the owner's family member wanted the house, Dimbleby and his business were evicted. He found that 179 Main Street was for sale, so that became the J.W. Dimbleby Funeral Home. It was also the family home; today, it is the home of John (Jack) and Judy Dimbleby.

This beautiful house at 100 Main Street in Whitesboro was the Wells & Lloyd Funeral Home, which had merged with the Friedel, Williams, Coriale & Edmunds Funeral Homes. The home was decorated for the town's bicentennial celebration, including a horse-drawn hearse on the front lawn. The building is now the Colonial Pharmacy.

The new J.W. Dimbleby Funeral Home opened in January 1986 on the site of the Oneida Institute at 40 Main Street. It has much more parking than the former location and can accommodate multiple calls at one time. In December 2005, a merger was made with Friedel, Williams & Edmunds Funeral Homes, making this the only funeral home in the village of Whitesboro. The fourth generation of the Dimbleby men to be funeral directors will happen when John Dimbleby completes his studies at Canton University, the alma mater of his father, Jim.

Five

FIRE DEPARTMENT AND POLICE DEPARTMENT

The early records of the Whitesboro Fire Department were lost many years ago in a fire that occurred on the corner of Main and Clinton Streets. The most that can be done is to present a fairly accurate consecutive narrative in which memory and tradition probably will both often be at fault. A short time after incorporation of the village in 1813, each freeholding resident was supposed to provide and maintain, in a readily accessible location, two leather fire pails or buckets. On occasion of fire, each resident, carrying his buckets, was to report to the scene of the fire, where, under direction of village officers, he was placed into one or the lines between the nearest water source and the fire. With the small buildings of the day, the bucket brigade undoubtedly did a good service.

With the growth of the village came the need for modern fire apparatus. Sometime prior to 1830, the village purchased its first fire engine. The Whitesboro Fire Department of today serves the community with pride. Special thanks to Whitesboro Fire Department historian Ray Daviau for his help with this chapter.

Few photographs exist of the early days of the Whitesboro Police Department. For many years, the department worked out of a two-room building adjacent to the highway department.

After years of patience and anticipation, the Whitesboro Police Department finally moved to its new location. The building is much bigger than the old two-room facility. The grand opening was held on Saturday, October 14, 2000. Whitesboro is very proud to have a well-respected police force to call its own.

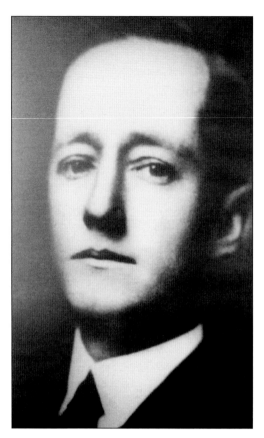

David E. Ellmore was the first fire chief (1922–1942), president of Babbitt Hose Company (1904–1945), and president of Oneida County Active and Exempt Firemen's Association (1912–1939). He passed away in 1945 at the age of 65.

Peter Sobel is the current fire chief, elected in 2005. Chief Sobel has served with the fire department for 25 years, 24 as a line officer. He is a former board of director. He also serves part time with the Whitesboro Police Department.

Frank Tobin Sr. was the first police chief. When he retired, his son Frank Tobin Jr. became the police chief of the village of Whitesboro.

This is the current police chief, Dominick Hiffa, who was sworn in on September 23, 1990. This photograph was taken in front of the municipal building. Erected in 1908, the structure once served as the fire station. During Chief Hiffa's tenure, a new police station was constructed on Roosevelt Drive.

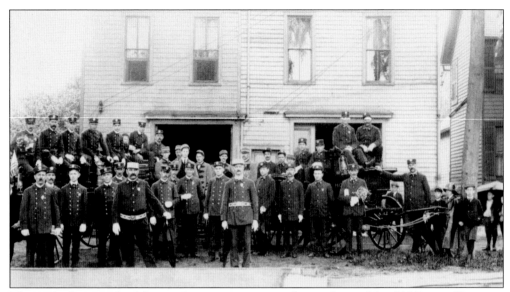

This early photograph of the two fire companies was taken in front of the Old Engine House on Moseley Street, which was torn down in 1908. The Babbitt Hose cart is at right. At night, the boys in the photograph would run in front of the hose cart with lanterns to guide the firemen to the blaze. It was a coveted job because the fire department would pay 25¢ per run. At that time, one company was the Independent Hook & Ladder Company, with George W. Eberley as president; J.R. Adams, first assistant chief; and Edward G. Gabel, second assistant chief. The other company was the Niagara Engine and Hose Company.

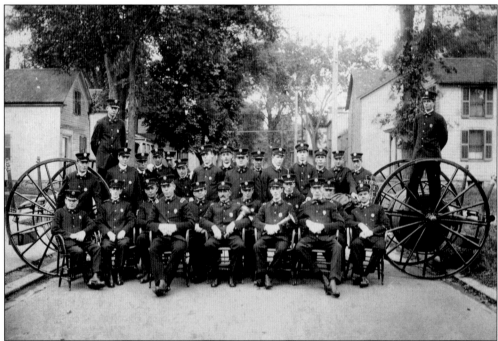

This formal photograph was taken on Moseley Street in front of the wooden firehouse on July 13, 1906. The men may have been getting ready for a parade, as they have the brass flower vases that the color guard carried along with the flags.

112

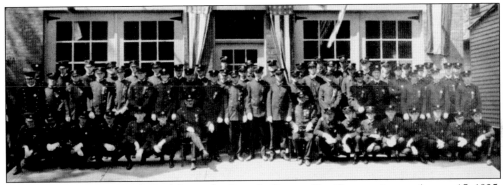

The firehouse is decorated to celebrate the Oneida County Fire Convention on August 15, 1925. Shown here are firemen from the Hook & Ladder Company and the Babbitt Hose Company. This firehouse was only 16 years old at the time, with the center door still there. It looks like most of the men in the village volunteered for the fire department, a necessity when a bucket brigade was the main source of fighting fires. Some names that might sound familiar are Melcom Gifford, George Bellamy, Harry Corts, Chief David Elmore, Mike Smith, Henry Ecuyer, Frank Tobin Jr., and Wayne Reeder.

This firehouse stands at 10 Moseley Street. The two doors that opened from the sides and the middle door were replaced by larger overhead doors. This photograph shows the tower that was used to dry the firehouse after the fires. The upstairs rooms were divided with beautiful oak pocket doors, separating the two companies at the time. The Babbitt Monitor Hose Company and the Hook & Ladder Company held meetings on the same night, but the doors were shut and locked between them. The two companies' officers were selected, one from each side to keep it democratic. This is the municipal building today. Upstairs is the home of the Whitesboro Historical Society and the D. Gordon Rohman Research Library.

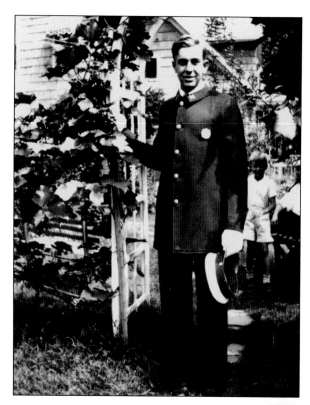

When young men turned 18 years old, they could join the Whitesboro Volunteer Fire Department. Casey Harp was 18 in 1931, and he was so proud to be a member. The uniform is brand new, and the shoes are polished. This uniform was used for parades. Looking on are his nephew Dewy Riemersma and his brother-in-law John, who shared Harp's pride in becoming a fireman. John Riemersma, a native of Holland, became a citizen of America by serving in the Army in World War II. He was very proud to say, "I fought the war in Hoboken, New Jersey, as a pastry chef one roll at a time."

This antique hose cart had to be pulled by hand to a fire. It is on display in the lobby of the present firehouse on Oriskany Boulevard. The lanterns had to be lit at night, and stories have been told about how hard it was to pull and push the cart up the hill and over the old Erie Canal bridges to get to fires on the upper side of the village.

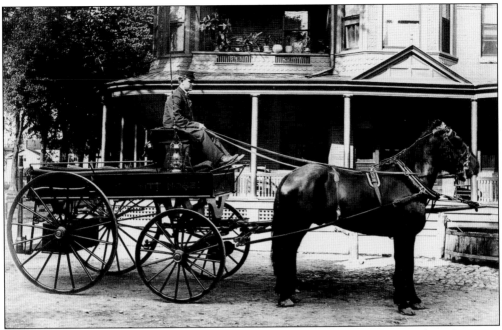

This hose cart was donated to the fire department by B.T. Babbitt ("the soap king"), a great supporter of the department. In the background is the Park House Hotel on the corner of Main and Clinton Streets, just by Village Green. The horse and cart has "B.T. Babbitt" on the side. In appreciation of Babbitt's donation, the fire department named one of its units the Babbitt Monitor Hose Company. The historical society has one of the old hoses on display at the museum. At far right is one of the water troughs for the hotel guests' horses and for the horses that pulled the trolley cars up Main Street.

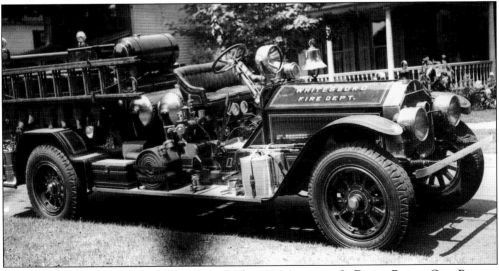

This fire truck was nicknamed "Old Betsey." The 1926 American LaFrance Rotary Gear Pumper could pump 750 gallons per minute with 120 pounds of pressure. It was donated to the American Museum of Firefighting in Hudson, New York. On Sunday, April 20, 1950, she was escorted to the museum by Chief George Bellamy of the Whitesboro Fire Department and by firemen Edward Zygmunt, Cornelius Harp, David Braun, and Charles Steiger, who took turns driving.

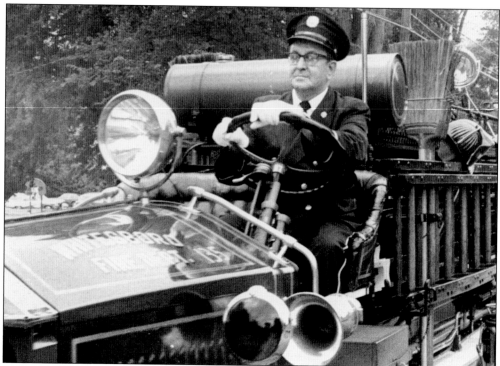

Deputy Fire Chief Casey Harp drives the 1927 Whitesboro hook-and-ladder truck in the bicentennial parade in 1976. The brooms on the truck were used to put out grass fires, which were frequent in the village until a ban was imposed on open burning of leaves and foliage. After parades, it was a treat for the children to sit in the fire truck and ring the bell. Many times, firemen gave out plastic fire hats to remember the occasion.

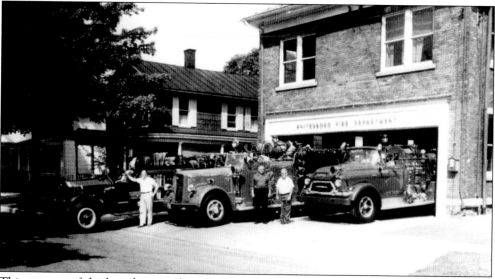

This was one of the last photographs taken in front of the Moseley Street fire station before it was replaced with the new one on Oriskany Boulevard in 1963. The fireman in front of the 1927 ladder truck is Ed Jones (left), the 1951 Ward LaFrance is pictured with Walt McCoyand (center), and Chief Charles "Chick" Bowen is with the 1953 American LaFrance (right).

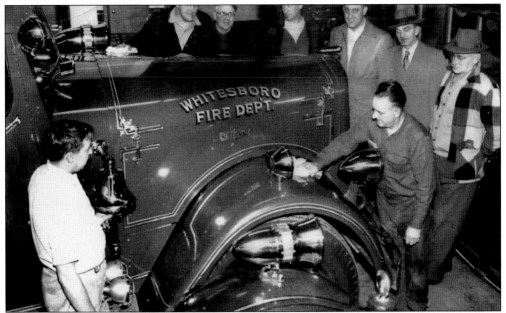

All fire companies take pride in the way they take care of their equipment. Shown here may be an inspection, at which time the fire department holds an open house. The mayor and the board of trustees inspect the trucks and the firehouse. Residents are invited to visit the firehouse, where refreshments are served. In the checkered jacket is Chief George Bellamy. The young man at left is George Massarotti Sr. He served many years as the treasurer of the department and celebrated over 50 years as a fireman.

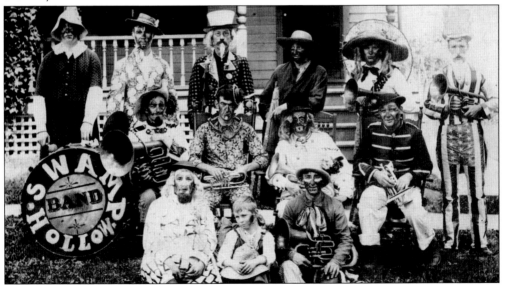

The Swamp Hollow Band's originator and conductor was James W. Brierly. They participated in parades, firemen's field days, and other local activities dressed as clowns, tramps, and even Uncle Sam. Despite having several accomplished musicians, the band's main forte was loud, discordant music. Pictured here (order unknown) are Jim Brierly, Bill Albro, Burt Sperry, Jim Coogan, Bill Blovise, Mort Swancott, Lou Collins, Bob Burkhardt, Earl Rahn, George Anderson, Bill Rice, and Frank Coogan. Some of these guys were members of the fire department.

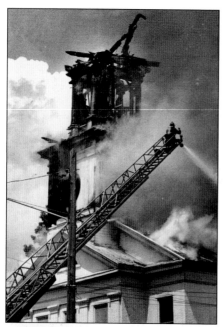

One of the biggest fires in the village of Whitesboro took place on July 19, 1979, when the historic Presbyterian church was destroyed while undergoing a $50,000 renovation. A person passing by looked up at the village clock and saw flames shooting from the steeple. Whitesboro called for help from the New York Mills, New Hartford, Yorkville, and Utica fire departments, but it was impossible to save the building. The bell fell through the rare Tracker organ, built in the 1800s, and the organ was ruined beyond repair.

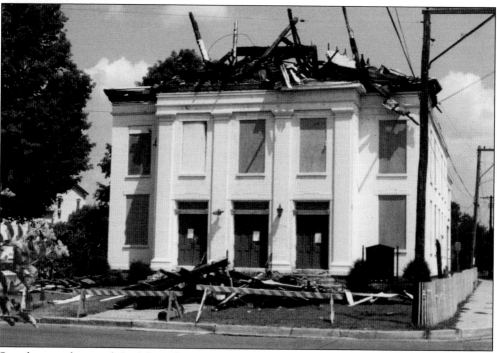

Seen here is what was left of the Whitesboro Presbyterian Church after the fire in July 1979. After an inspection, the people of the church family decided to rebuild the old historic church. The original furniture from the altar had been stored in the Sunday school building on Elm Street. The furniture is used in the church today. The people of the defunct Sayre Memorial Church donated their 1883 Tracker organ, one of fewer than 20 still in existence. The organ was built by John Marlowe of Bleecker Street in Utica. Pews and lights were also donated from the Sayre Memorial Church in Utica, New York.

When the Whitesboro Presbyterian Church was rebuilt, there were insufficient funds to replace the steeple, which had held the village clock since 1886, when the village board voted to buy a Howard clock for $500. The Presbyterian church gave permission to use its steeple for the clock. The village agreed to maintain the clock, appointing Isaac Cooper the first "keeper of the clock" at an annual salary of $30. Shown here is the delivery of the steeple in 1989 in sections. Once again, the village clock was in place.

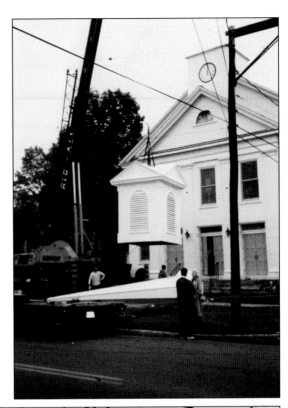

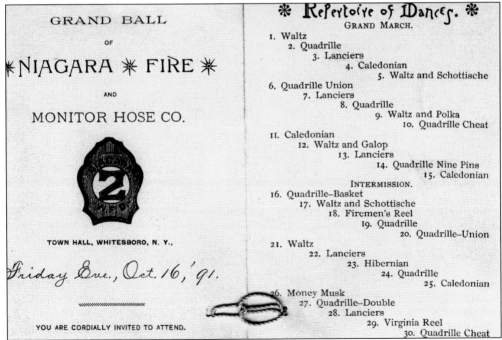

GRAND BALL

OF

⋇NIAGARA ⋇ FIRE ⋇

AND

MONITOR HOSE CO.

TOWN HALL, WHITESBORO, N. Y.,

Friday Eve., Oct. 16, '91.

YOU ARE CORDIALLY INVITED TO ATTEND.

⋇ Repertoire of Dances. ⋇

GRAND MARCH.

1. Waltz
2. Quadrille
3. Lanciers
4. Caledonian
5. Waltz and Schottische
6. Quadrille Union
7. Lanciers
8. Quadrille
9. Waltz and Polka
10. Quadrille Cheat
11. Caledonian
12. Waltz and Galop
13. Lanciers
14. Quadrille Nine Pins
15. Caledonian

INTERMISSION.

16. Quadrille–Basket
17. Waltz and Schottische
18. Firemen's Reel
19. Quadrille
20. Quadrille–Union
21. Waltz
22. Lanciers
23. Hibernian
24. Quadrille
25. Caledonian
26. Money Musk
27. Quadrille–Double
28. Lanciers
29. Virginia Reel
30. Quadrille Cheat

In former days, fire department dances were formal affairs. The invitations were quite fancy. This is an invitation to the 1891 Grand Ball for the Niagara Fire and Monitor Hose Company. Note the schedule of dances for the night.

119

Harold Kaffka served as a police officer under Chief Frank Tobin Jr. When Tobin retired, Kaffka became chief of the Whitesboro Police Department. Very few photographs exist of the Whitesboro police because, unlike other departments, it did not have a historian. In the early days of the village and town, policing was done by the county sheriff. Early departments consisted of a chief and a patrolman. Today, the police force has 10 officers, part time and full time.

Six

FAMILIES AND HOMES

This pictorial history ends the way it began, with Hugh White and his pioneer spirit, his friendship with the Oneida Indians, and some of the early homes of his namesake village and town. Hugh White conquered the wilderness to make a better place for his family, using the fertile land to provide sustenance. He maintained his faith, beginning worship with a gathering in his barn, and gifted one of the last historic buildings left in the village, the town hall. Judge Hugh White was a very honorable man.

The Oneida Indians resided at Oriskany when Hugh White came from Connecticut. After many friendly visits between the two, Indian chief Han Yerry asked White, "Are you my friend?" White replied, "Yes, I am your friend." The chief asked him to prove it. The trust of the two friends was put to the test when the chief asked to take Hugh White's granddaughter to stay one night, from sundown to sunup. Proving his confidence in the word of the chief, Hugh White gave him permission to take one of his most valued possessions, his granddaughter. After a very long night and a mother's constant look at the horizon, at sunrise, the chief and his wife returned the child in full Indian garments and declared her an Indian princess and Hugh White a true brother.

Under the provisions of Chapter 191, Laws of New York, a 1919 act amended the education law in relation to local historians. It became the duty of the proper authority in every town, city, and village of the state with less than one million persons in population to appoint a local historian. Under the provisions of this act, a Whitesboro village historian was appointed. The position of village clerk was also appointed. With this in mind, the authors wish to thank Mayor Patrick O'Connor, Deputy Mayor Robert Friedlander, and trustees Beth Park, David Glenn, and Vincent Malagese for providing the opportunity to make this book a reality.

The future goal for the Village of Whitesboro is to preserve the town hall and the collection of history shared in this book.

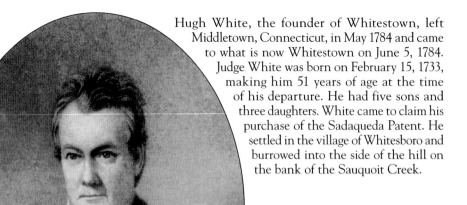

Hugh White, the founder of Whitestown, left Middletown, Connecticut, in May 1784 and came to what is now Whitestown on June 5, 1784. Judge White was born on February 15, 1733, making him 51 years of age at the time of his departure. He had five sons and three daughters. White came to claim his purchase of the Sadaqueda Patent. He settled in the village of Whitesboro and burrowed into the side of the hill on the bank of the Sauquoit Creek.

This photograph was taken during the centennial celebration in 1884 on the porch of Hugh White's house, located in the park. The dedication of the obelisk, a symmetrical shaft of Quincy granite rising 30 feet from the base, was the centerpiece of the event. The inscription on the obelisk reads, "To Commemorate the First Settlement of Whitestown by Hugh White and Family, June 1784." This photograph was donated by Teddie White Mulceahy to the Whitesboro Historical Society

The handcrafted natural stone pillars and gate are at the entrance to the George E. Dunham summer estate on the top of Harts Hill on Clinton Street. The home was called Bryn Hughston by the owners because *Bryn* is the Welsh word for hill and Hughston was his mother's maiden name. This is the same Dunham who donated his father's home on Main Street in the village for the Dunham Public Library. The gardens were magnificent. It was Helen Dunham's hobby to garden. The entrance is still on the property today.

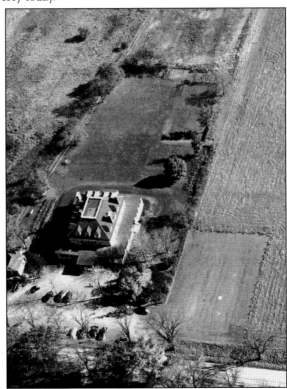

This aerial photograph shows the summer home of the Hart family, of Hart & Crouse Plumbing of Utica. The property today is known as Harts Hill Inn, on Clinton Street in Whitesboro. The land behind and beside the building is the Dunham Manor Housing Development today. The families who owned these summer homes lived in the mansions of the city of Utica. When the weather got warm, they would pack up the horse-pulled wagons filled with household things, and the servants and the family made the long trip to Whitesboro, up the hill that is Clinton Street today.

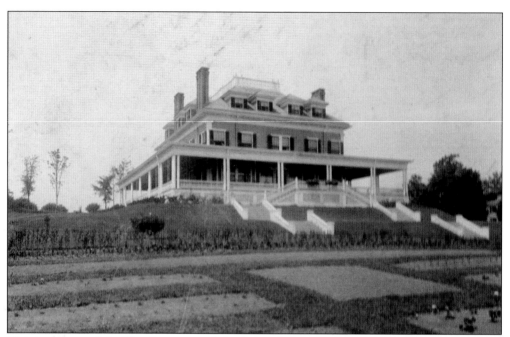

This back view of the Hart home reveals landscaped grounds. When this building became the Plantation Restaurant, guests could stay in the rooms off the balcony, with a grand view from the wraparound porch, complete with white rocking chairs.

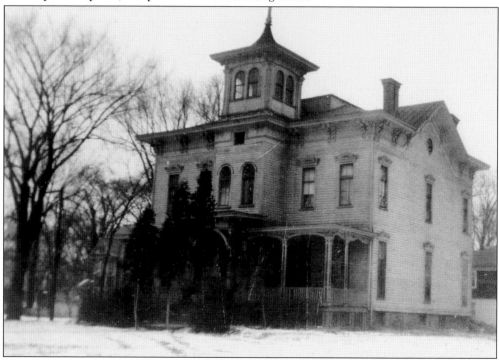

This property, on the north side of Main Street at Dennison Avenue, was owned by Dr. S.L. Gifford. The house was originally the homestead of Thomas R. Gould. The original house on this property, built in 1796, was removed in 1867 to the opposite side of the street, where it stands today.

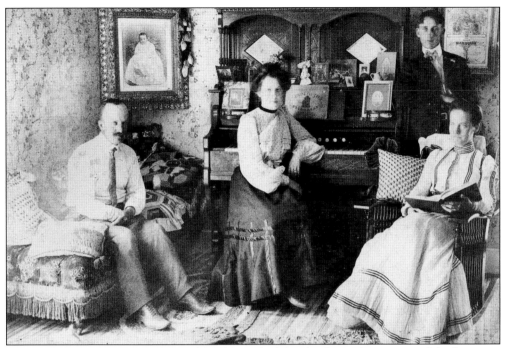

This late 1800s photograph, donated by the Gifford family, shows the interior of the home on Main Street and Dennison Avenue. They were one of the more affluent families, as is evident by the organ and other furnishings of the home.

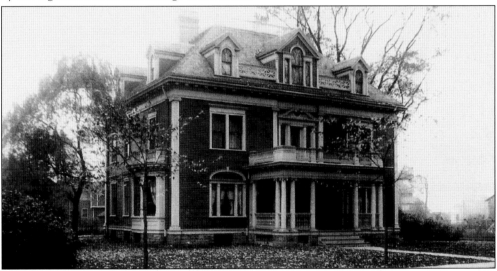

This was the home of the author of *The Widow Bedott Papers*, Miriam Berry Whitcher, at 100 Main Street. Originally, in 1780, a tavern in the back portion was operated by Daniel Clark White, son of Hugh White. Miriam Berry anonymously satirized the manners and morals of her Yankee neighbors in Whitesboro. In January 1847, she married Rev. Benjamin W. Whitcher, the Episcopal minister of St. John's church. When her articles started appearing in the *Godey's Lady's Book*, the residents recognized themselves, and the church put pressure on her husband to make her stop. After her death in 1852, Benjamin remarried, and his second wife published the sketches as a book in 1855.

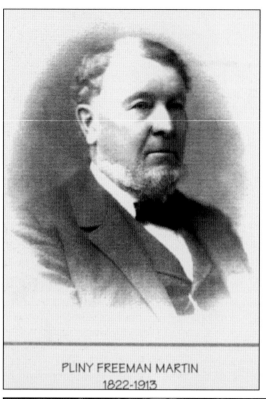

Pliny Freeman Martin lived in the house in back of the Berry property at 100 Main Street. The house was a beautiful, stately home of fine architecture with a widow's walk at the top of the roof. When William G. Stone, local historian, wrote *Historical Reminiscences* in 1922, the Martin house was already 100 years old. Pliny Martin was the oldest resident of Whitesboro, 91 years old in 1913, when he passed away. He began his career as a hotel proprietor at the Elm House, which stood on the corner of Main and Mohawk Streets opposite the Park House. He ran the Mansion House and stables in Utica. He was a pillar of the Presbyterian Church.

PLINY FREEMAN MARTIN
1822-1913

This was the home of Thomas Henry Farrell, MD, on property purchased in 1910 from George Dunham. The two men became friends when they both lived on Park Avenue in Utica. The home was called Carrick House, after a Welsh estate, as it was the fashion in those days to name a home after European properties. The home had beautiful gardens that are now part of the Herthum Heights development. The house later belonged to Dr. Ed Gaffney; it may still be in the Gaffney family.

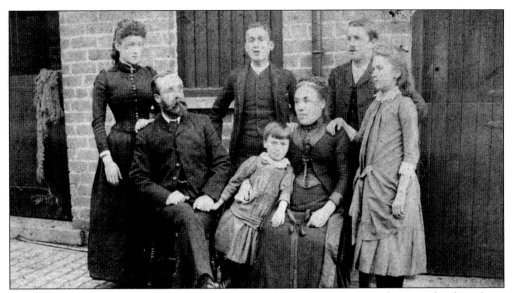

The Evans family lived next to the firehouse on Moseley Street. It is not known why they chose to have their photograph taken in front of the old jail and barn behind the station. The barn was used for the village pound, where any horses, cows, and pigs found roaming in the village were kept until the owner paid a fine of $2 and reclaimed them. The jail was mostly used to allow people to sleep off too much celebrating at the local pub. The backyard of the Evans family's home was entirely dedicated to gardens, so the flat spot in front of the jail must have been the next choice for a photograph setting.

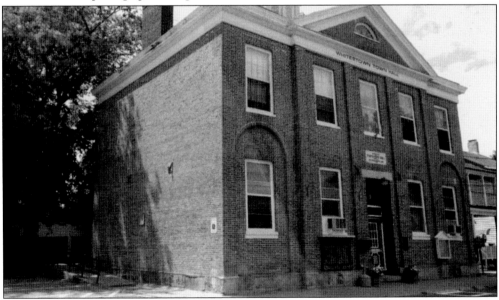

In 1801, Hugh White deeded one acre of land to Oneida County to build a courthouse and jail. After serving nearly 50 years, the courts moved to Utica. The property reverted to the heirs of Hugh White for a brief time, until his grandson Philo White re-donated the site to the Town of Whitestown and the Village of Whitesboro. The town hall stands today as it did upon completion in 1807. It currently serves as the Village of Whitesboro Court and is in the National Register of Historic Places.

DISCOVER THOUSANDS OF LOCAL HISTORY BOOKS FEATURING MILLIONS OF VINTAGE IMAGES

Arcadia Publishing, the leading local history publisher in the United States, is committed to making history accessible and meaningful through publishing books that celebrate and preserve the heritage of America's people and places.

Find more books like this at
www.arcadiapublishing.com

Search for your hometown history, your old stomping grounds, and even your favorite sports team.